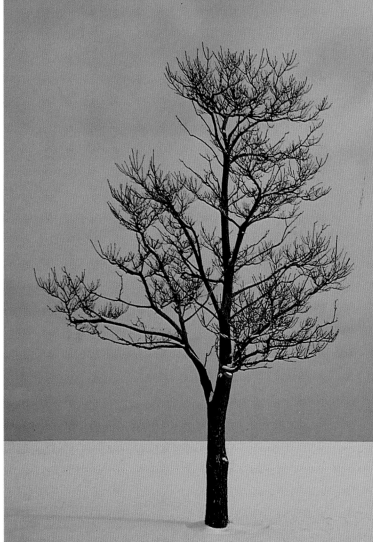

COLOR VISION

JOE MARVULLO

AMPHOTO
AN IMPRINT OF WATSON-GUPTILL PUBLICATIONS/NEW YORK

TO MY FAMILY

Joe Marvullo is a professional photographer who lives and operates a studio in New York City. He lectures throughout the United States as a principal instructor for the Nikon School of Photography. His clients include IBM, Citibank, Pierre Cardin, British Airways, Swissair, Mobil, and ABC-TV.

Graphic production by Ellen Greene

Copyright © 1989 by Joe Marvullo

First published 1989 in the United States and Canada by Watson-Guptill Publications, a division of Billboard Publications, Inc., 1515 Broadway, New York, NY 10036.

Library of Congress Cataloging-in-Publication Data

Marvullo, Joe.
 Color vision / Joe Marvullo.
 Includes index.
 ISBN 0-8174-3675-8 ISBN 0-8174-3676-6 (pbk.)
 1. Color photography. I. Title
TR510.M32 1988 88-33993
778.6—dc19 CIP

Manufactured in Japan

1 2 3 4 5 6 7 8 9 / 97 96 95 94 93 92 91 90 89

CONTENTS

INTRODUCTION

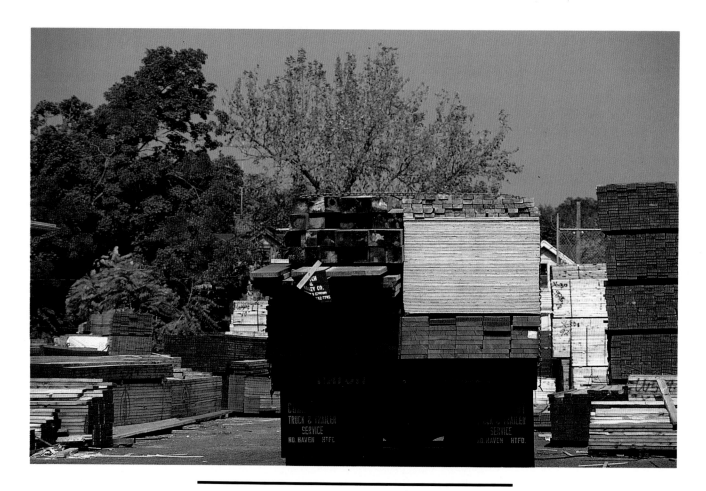

On a clear autumn morning in a Connecticut lumberyard, I found this vivid representation of color vision. The three primary colors of light—red, blue, and green—harmonize in this photograph of planks of wood juxtaposed against the foliage and "pull" the image together. Photographers must decide which part of a scene will have the most graphic impact. Here, I used a 135mm lens and Kodachrome 64.

"BROUGHT TO YOU IN LIVING COLOR."

The Color Purple, Pretty in Pink, The Color of Money. "Blue Velvet," "The Yellow Rose of Texas," "Red River Valley," "Blue Moon," "Purple Rain," "Mellow Yellow," "Blue Suede Shoes." Deep Purple. The White Album. The Orange Bowl, the Rose Bowl. Scarlett O'Hara. Greener pastures. Scarlet fever. Lily white skin. I got the blues. Green with envy. Black is beautiful. The grass is greener on the other side. Three cheers for the Red, White, and Blue. These phrases refer to far more than color content. They have deep psychological roots and elicit emotional reactions.

Color also has an enormous effect on us physically. We guide ourselves through the physical world by using a combination of senses. Because our environment is defined by the visible spectrum—the wavelengths of light—sight is the most important faculty in terms of orientation and perception. It is light that enables us, in part, to see, and where there is light, there is color. We are enveloped by it. The sky and the ocean, the grass and the buildings, rocks and metals, all appear to have color. But objects actually have no color at all; the colors we see are simply reflected rays of colored light bouncing off the objects themselves.

Since we view life in varying degrees of color, color is vital to the creation of any photographic idea. This makes color photographers unique among artists in that they deal with a natural element (light) and an unnatural one (film). Light's profound influence on the environment and film's ability to record it, as well as the psychological and emotional effects of perceived colors, convey messages through one of the pictorial languages of visual thinking, the photograph.

Photographers who shoot in color have to be able to imagine what the final photograph will look like. They have to carefully consider the camera angle, the balance of the color composition, the focal length of the lens, the correct aesthetic or technical exposure, and the texture of the photograph. All of these various components will determine both the meaning and the impact of the picture. In order to translate a photographic idea into an effective, successful image, photographers must appeal to the viewer's sensibilities and establish an awareness of a place in space and time that never actually existed. The transformation of a three-dimensional live scene into a two-dimensional man-made colorization on film, frozen at a millisecond and seen and recorded through optics alien to normal human vision, is the framework in which modern photographers work.

The camera meets an image filled with color and responds to the photographer's vision of both. That's *color vision.* The word "photography" comes from the Greek and means "to write with light." As photographers, this is what we do. We follow the magical metamorphosis of light throughout the course of the day and night and make photographs accordingly. Light, color, and subject are the fundamental components of an image, while the photographer's understanding of exposure, lenses, and ideas are the tools used to convey a personal interpretation of a living scene.

The personality of color is determined by two distinctly different characteristics. The first is the "soul" of a color, its hue. There are hundreds of hues of the color red. However, when the other component of a color—its "saturation" or lightness—are added, a seemingly endless number of combinations become possible. Saturation describes the amount of hue in a color. For example, crimson red or vermillion have large amounts of red in them, while there is very little red in pink. The lightness of a color tells, obviously, how light or dark a color is. Pink is a light color because it

contains a great deal of white. The terms "value" and "chroma" stand for the amount of lightness or saturation in any given hue. Photographers primarily react to these millions of colors and how the brightness or absence of natural or artificial light affects them from an aesthetic viewpoint.

Just after sunrise and sunset, there are mild variations of light, and soft, serene colors are uniformly calm, neither jumping out nor screaming for attention. Even the strongest color contrasts are merged in the limited palette of pastels joined by the muted lighting.

Afternoon's bright sunlight, with its deep shadows, high contrasts, and explosive colors, reveals colors at their peak. Distinct outlines and unmistakable detail create well-defined, powerful color renditions. Also, an uneven distribution of shadow and light can mean uneasiness, even color tension.

All light, whether natural or artificial, is a product of the emission of photons, or packets of light energy. A visible form of radiant energy, a small part of the electromagnetic spectrum that ranges from X-rays to radio waves, light must be understood—both what it is and what it does—for photography to be understood.

When the filament of a light bulb is sparked by an electric current, the filament's atoms oscillate from a lower energy level to a higher level and back again. As these atoms descend to a lower energy level, they emit photons that travel in waves. The photons' different levels of energy make up light's varying wavelengths.

And wavelength determines color. Blue wavelengths are the shortest and most energetic; red wavelengths, the longest and least energetic. White light consists of all colors, a mixture of photons of wavelengths covering the entire range of visible light.

Reflected light is thrown back at the same angle, as with a mirror. Refracted light is scattered, as by water, or absorbed, as by most solids. Metals and mirrors, which are smooth surfaces, return light in an organized fashion, thereby producing an exact image.

The refraction of light makes clouds—which are actually transparent water droplets—appear as white forms, as light waves refract haphazardly through the droplets and reflect off the surface of the water.

So, too, sunlight is bent as it passes through the atmosphere of the earth and its small particles of dust and water. Sunlight contains wavelengths of all colors; the scattering affects the blue end of the spectrum—the shorter waves—more than it does the longer wavelengths at the red end. At noon, then, when the sun is directly overhead, we see a blue sky, a yellow sun, and white daylight.

At sunrise and sunset, with the sun low on the horizon, light waves meet a greater number of atmospheric particles. As a result, more blue light is scattered and red waves predominate, creating a reddish glow in the sky as well as orange sunsets. Ironically, industrial pollution is responsible for the most dramatic sunsets.

Light is the subject of this city scene, taken in North Carolina on Fujichrome 100 with a 28mm lens. The reflective surface of the glass building across the street creates a pattern of light and shadow on the orange brick wall.

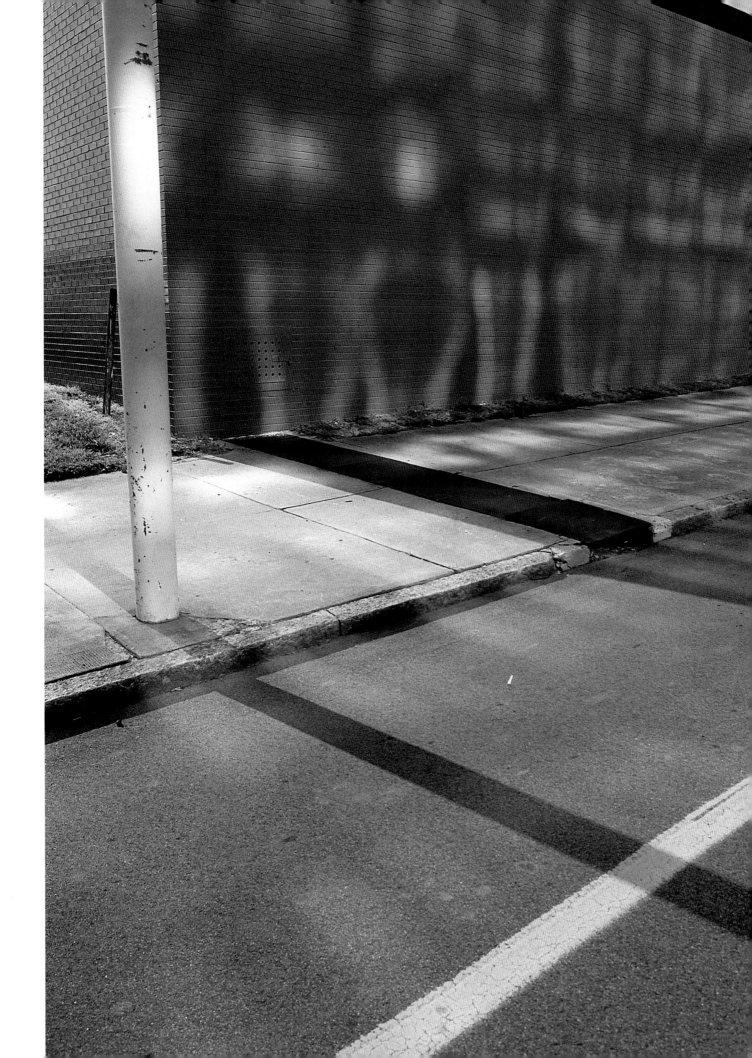

A solid object will generally absorb some of the light that reaches it—depending on its molecular structure—and will reflect the rest, leaving us with what is left of the spectrum: the color we see. An apple looks red because it absorbs all the visible wavelengths except for those that make up the color red.

Color relationships can be more easily visualized by "seeing" the colors of the spectrum bent into a circle, with red and blue ends meeting, since the spectrum blends one color into another, from violet through blue, green, and yellow, to red. Red, blue, and green are the primary colors of light; by mixing them you can form any color in the visible spectrum. White light is what you get when you put them together. Each of these primary colors has a complementary color. Yellow is the complement of blue, magenta of green, and blue-green (cyan) of red. Complementary colors are opposite each other on the color wheel. Color by subtraction, or subtractive color mixture, forms the basis of almost all color photography.

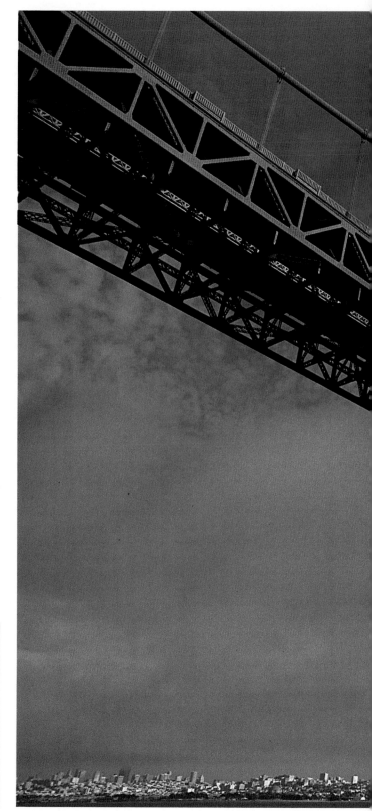

The brightness of late afternoon light is evident in this wide-angle shot, taken with a 21mm lens and Fujichrome 50. The exaggerated perspective of the Golden Gate Bridge adds to the dramatic golden orange of the structure against the blue sky. As this image shows, the bridge's name is appropriate.

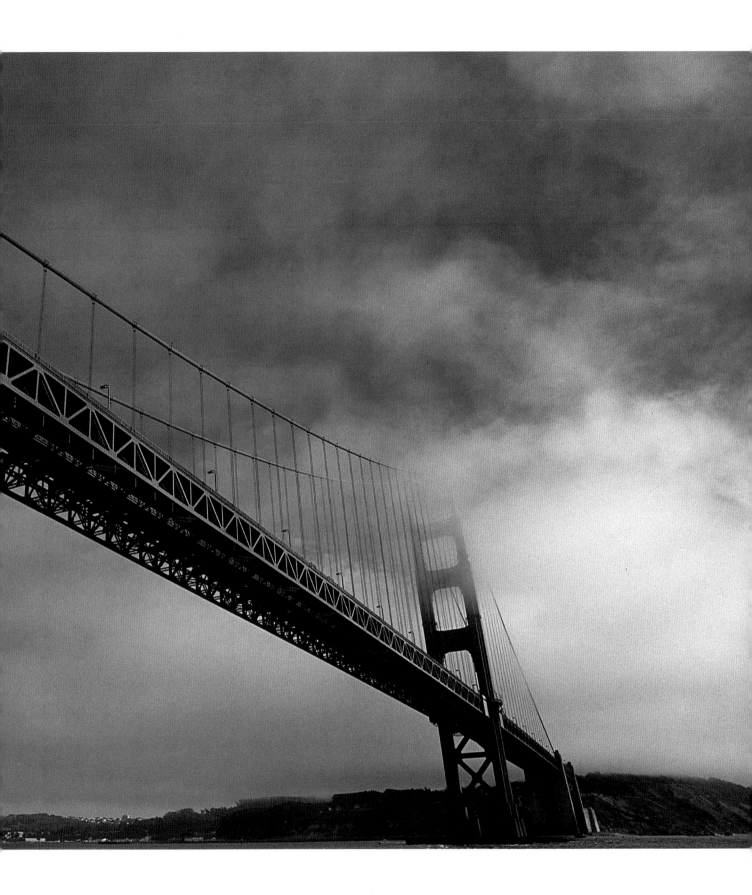

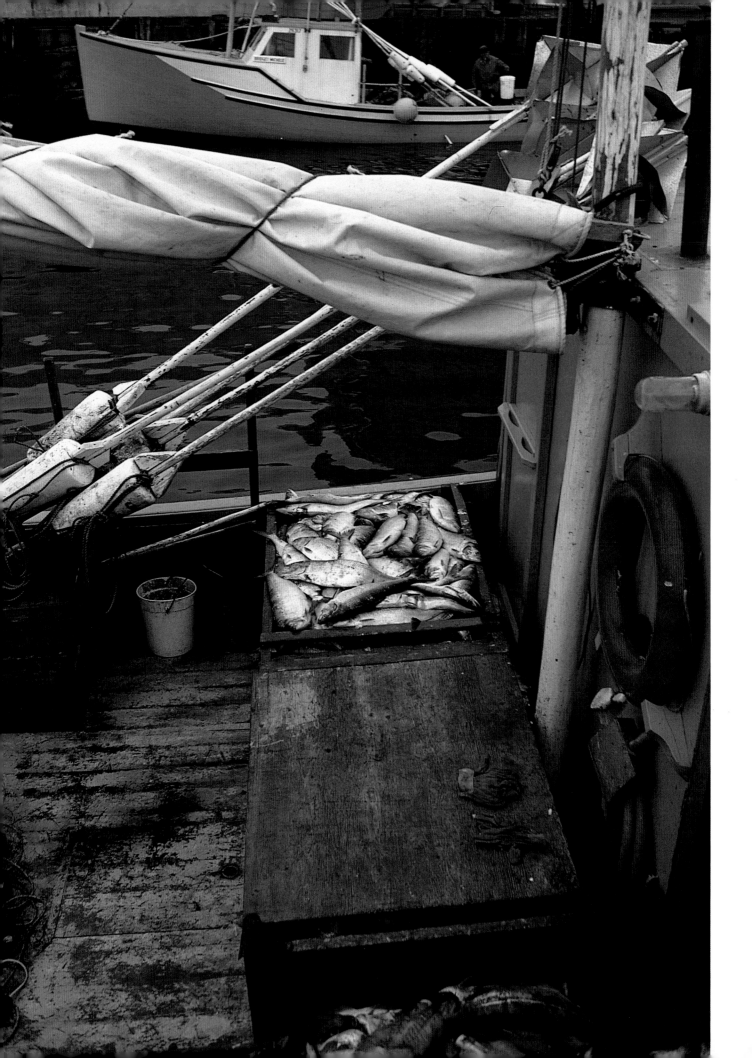

Color film is composed of three main layers, each of which is sensitive to one of the primary colors; this is true for all color film, both slide and negative. Together they can respond to and reproduce any color in the visible spectrum. These layers are stacked. The first is sensitive to blue light, the second to green, and the third to red. After the first layer records blue light, a filter layer of yellow material screens out excess blue. Green is recorded next, and red follows. Finally, a layer known as the anti-halation block is used to absorb all the remaining light.

The film's three separate images are dyed in the development process; they are not actually colored. A silver image forms on each layer of emulsion as a chemical developer changes the exposed salts of the film to metallic silver. Within each layer, a chemical substance called a "coupler" forms a colored dye by joining with the chemicals in the developer. Each layer forms a different dye, the complementary colors of those colors originally recorded. When white light, which contains all three primary colors, is passed through the complementary color—as it does when a slide is viewed through a projector—the primary color is filtered, leaving the original color to be reproduced.

The color, intensity, and angle of light determine the brightness of a photograph. Saturation increases the depth of feeling of a color. The essence of the color lies in its saturation, which is accomplished by letting less light in by slightly underexposing.

Light is a photographic design element as well as the basis for temperature in a photograph. It controls the density of color.

Whether you create personal portraits, photojournalism, or still lifes, it is color that will bring your vision home. Color has themes as well as strengths and weaknesses and, like light, is a potent force.

Color is powerful. We respond to it intellectually, emotionally, and physically. Color lives. It has moods: it is aggressive—hot reds—and passive—cool blues. Colors can seem harmonious or at odds with each other, creating tension. A fresh look at light and color is important to all photographers who want to work well with color and have greater control over it.

An overcast day and a light drizzle brought out a chromatic effect in the colors of these fishing boats in a small port in Nova Scotia, Canada. Wet surfaces are ideal for photographing without stark light and shadow: the overall flat lighting brings out a "softness" in the saturation of the hues. Using Kodachrome 64 and a 35mm lens, I composed this busy picture carefully to make it appear balanced.

THE PSYCHOLOGY OF COLOR

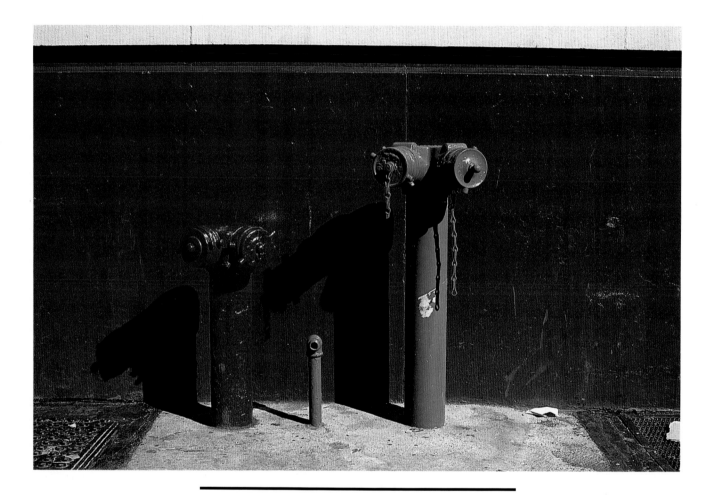

The siamese connectors with their green "Yes" and red "No" give a clear message. Bright midday sun intensifies the hues and creates dense black shadows, which were incorporated into the design of this streetscape, taken with Fujichrome 50. I used a low angle to look directly into the "eyes" of the small robotlike fixtures, using the perspective of a 50mm lens.

THE COMMUNICATIONS revolution has hurled us into a new dimension of perpetual, artificial color. We now have a mirage world of illuminating symbols and signs that send glowing, flashing, coded messages by the millions. In this new age of information, the way those millions of messages are sent means that light and color play the most significant role: they constitute the means for relaying visual signals instantaneously and with a "high-tech color punch." Today, more colors are available for the human eye to behold than ever before. True color and artificial color have become blurred.

Each person may, in the course of a single day, see hundreds or even thousands of color signals in every degree of intensity, shape, and size. Some are deliberately designed graphics, such as neon signs and advertisements designed to catch the eye and make a certain impression that will color-identify a product; these may be sought after, but they may also be forced to an unsuspecting viewer. The colors of television commercials are clear examples of this visual assault. Reds and yellows scream color alerts, over and over, through the tube; reds and blues—powerful signals—thrust viewers into prearranged color scenarios: red is hot and sexy and not to be confused with amber-yellow, which is for good times and sun; blue is tranquil and comforting; green represents menthol, fresh and outdoors. This is intrusive color, identifying moods and messages and mounting a color-assault on the senses, an assault that the people of the twentieth century contend with, create, digest—and prosper by.

Red . . . Blue . . . Green . . . Yellow . . . Orange . . . Purple. Instant color signals. Messages. The human emotional response to color wavelengths, whether by word or by sight, is an integral part of everyday existence. We see colors in space, in free-form constellations of lights and reflections, in endless combinations of lightness and intensities of brightness, connected by harmonies of hue and parallels of emotional response.

Colors are the visual "feelers" through which we, as communicators, relay our thoughts and information.

We all speak the language of color. It has its own dialects and semantics, to be sure, but these all stem from the same visual roots. Parallels between the chords and scales of musical keys and the hues, tints, and shades of the color scale have been pointed out often enough, along with analogies to the major and minor keys of music. Like music, color demands attention as an instantaneous experience.

In daily, recurring encounters with color, lights, and reflections, we react in accordance with atmospheric levels set by light and color: the natural colors of landscape, the artificial colors of cities—everything is alive with combinations and harmonies that will change progressively during the day from the light and color of morning through countless gradations of tints and shades. Bright light and low diffused light make their presence felt as color shifts and moods change; long shadows and precise highlights, even the absence of light—all these affect the "personality" of color. This continual movement of color wavelengths and the effect it has on our human psyche are the essence of what I call "color vision."

The glowing yellow safety stripes of a firefighter's slicker and the easily identifiable fire-engine red were photographed in the open shade in New York City with a 35mm *f*/2 lens and Fujichrome 50. The Day-Glow yellow can be seen at great distances, as well as in fog, in smoke, and at night.

An emergency signal in graphic action on a side street in New York City, the bright glow of the flashing yellow arrow was frozen at 1/25 sec. with a 28mm lens wide open at *f*/2.8. The intensity of the red and orange lights in focus, contrasted against the slightly cooler colors of the out-of-focus background, emphasizes the sharp "Alert!" of the yellow arrow and lights of the foreground. I used Fujichrome 50 here.

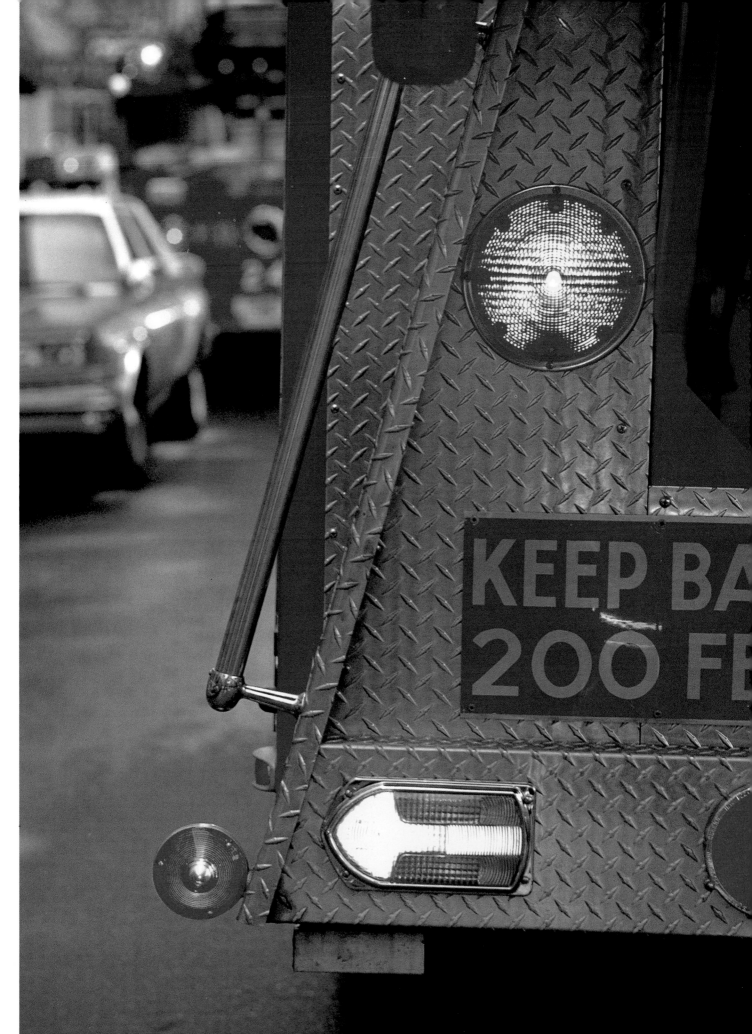

KEEP BA
200 FE

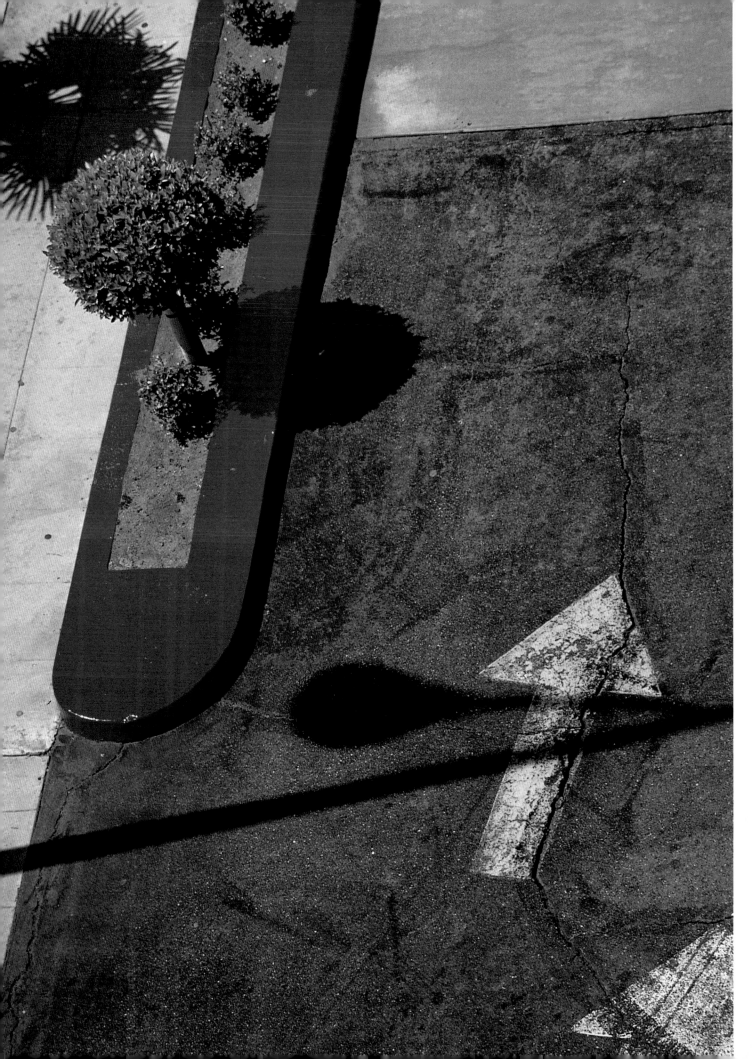

The clarity of early summer days as seen in this picture makes for photographs that can be not only bright in color but also extraordinarily vivid. The chroma of the blue sky and of the yellow dividing lines were further saturated through the use of a light-polarizing screen. The color yellow can be seen at great distances as well as in adverse weather conditions, such as rain or fog, and it reflects well at night when headlights hit road dividers and traffic signs. The extreme-wide-angle view was achieved with a 20mm lens.

From my Hollywood, California, hotel balcony, I was struck by the array of color signals used as traffic directors in the driveway below. I used a 180mm lens to realign the symbols and make a new design pattern, incorporating the shadows of unseen objects. I shot with Fujichrome 50, and the three colors that were used for traffic directions because of their eye-catching qualities—red, yellow, and white—were squeezed together for the composition.

We are so alert to the extraordinary brightness of a color such as this, especially when it stands out against the featureless background of wet gray cement, that we are psychologically forewarned. The backlighting of the translucent plastic ribbon and its diagonal stretch across the frame add to the dynamism of the picture. This closeup view was shot with a 35mm lens in strong directional light in New York City.

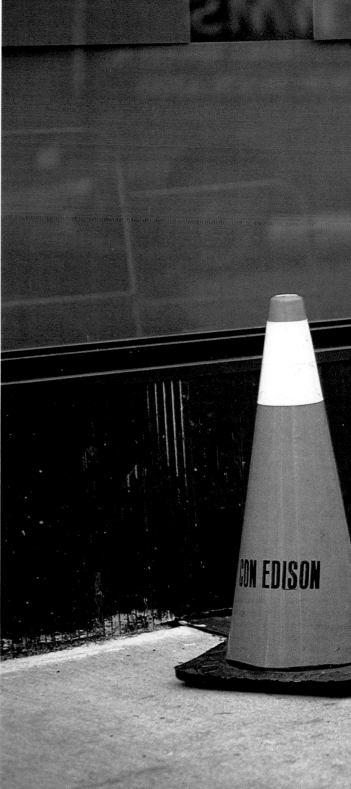

Color is the message in this utilitarian color scheme photographed in New York City with a 35mm lens. I noticed the brilliant cones almost vibrating in the shade alongside the yellow guardrail. The deep purple in the window and the black wall further enhance the characteristic way orange and yellow make subjects seem to advance toward you.

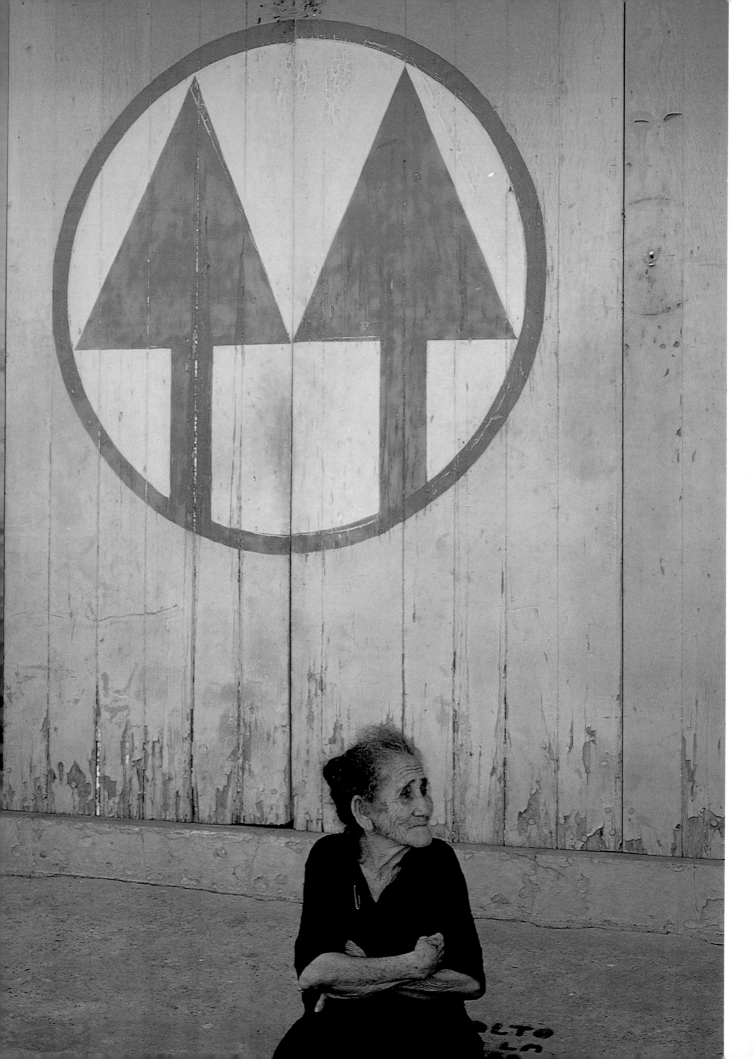

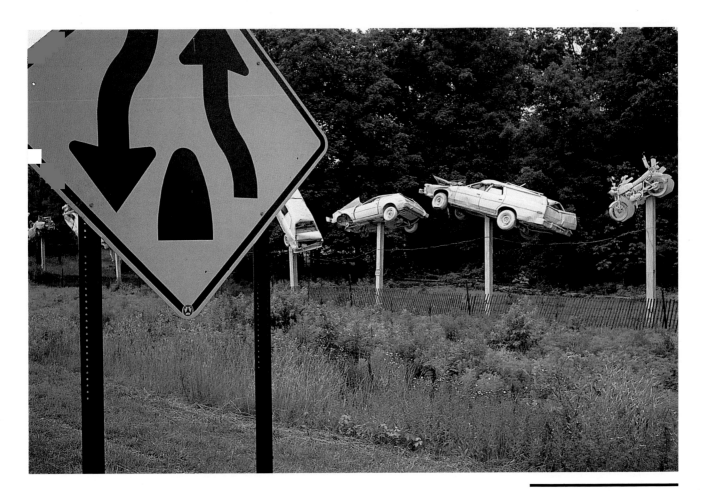

This ghostly scene of images and symbols, which I mixed together to make a new impression of another artist's statement, was taken in rural Pennsylvania. It represents automobile fatalities along one highway. I needed the depth of field provided by a 35mm lens to pull together the yellow traffic sign and the white-painted cars and motorbike. The day was overcast, and this added to the somber tones of this surreal scene.

At last light on a small rural road in Puerto Rico, I was able to photograph a woman sitting in front of this incredible wall graphic. The yellow circle with arrows pointing upward and the green background of the wall become a fantastic setting for the black-garbed woman sitting in front, apparently oblivious to it all. By using a 28mm lens, I was able to keep good depth of field even in low light. And, because of this low light, the overall feel of the picture is of a cool green despite the strong yellow in the mural.

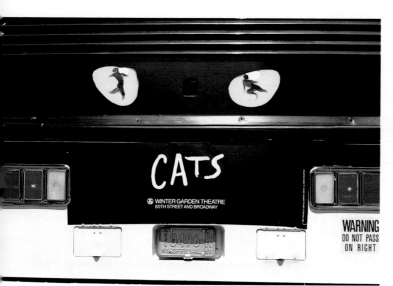

The bus carrying this ad for a play was pulling away when I caught it with a 90mm lens at 1/500 sec. The yellow of the eyes of the cat combine with the exterior details of the bus to emphasize the power of yellow. Metallic highlights enhance the graphics.

Two icons of 1950s America hang beside Old Glory on a street in New York City. The psychological effect of these images is further heightened by strong identifying color: Elvis's sexy red shirt against tranquilizing blue, Marilyn's famous blonde halo against a hot red backdrop. Cloudy overhead light lowered the contrast level and increased the chroma of the colors. A 90mm lens was used at eye level to heighten the immediacy of the images.

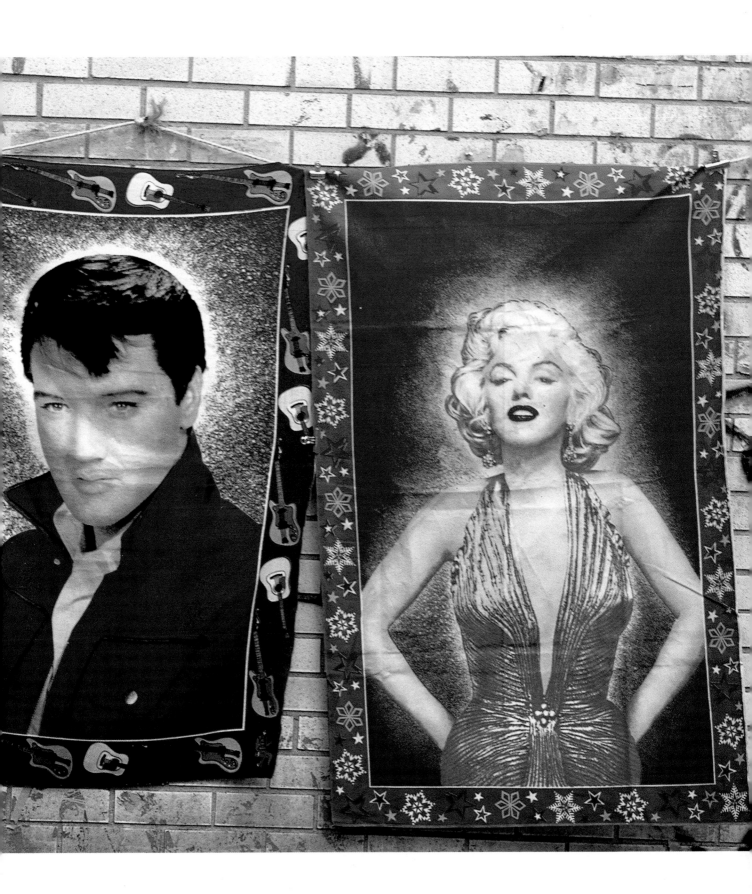

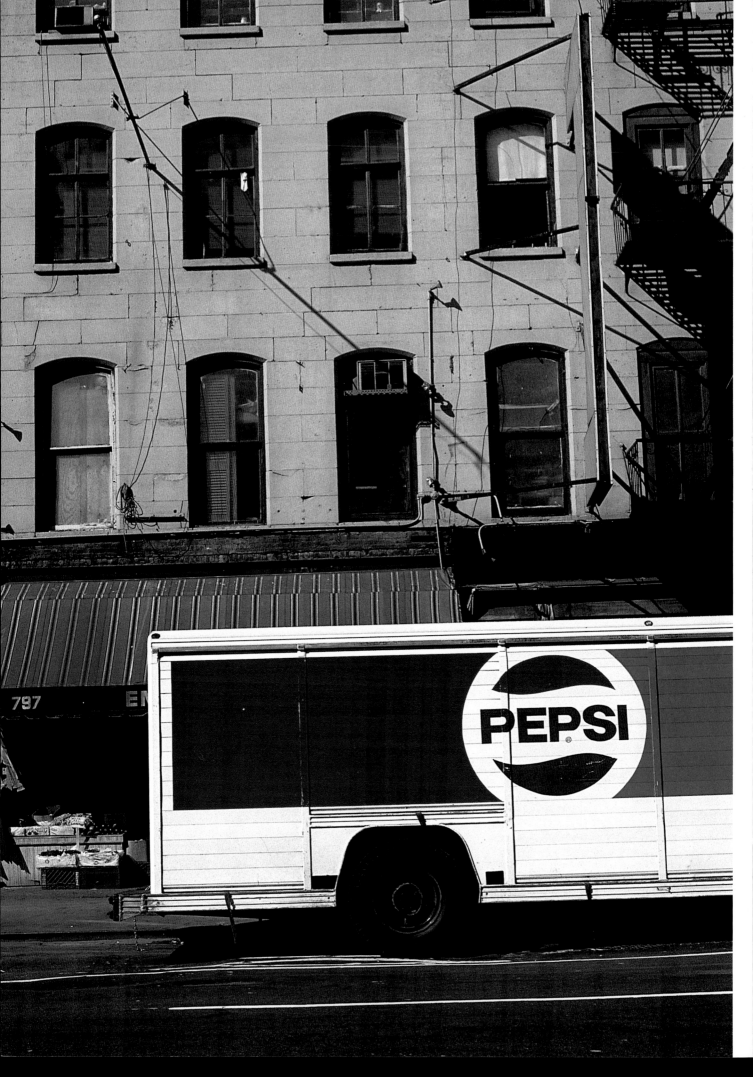

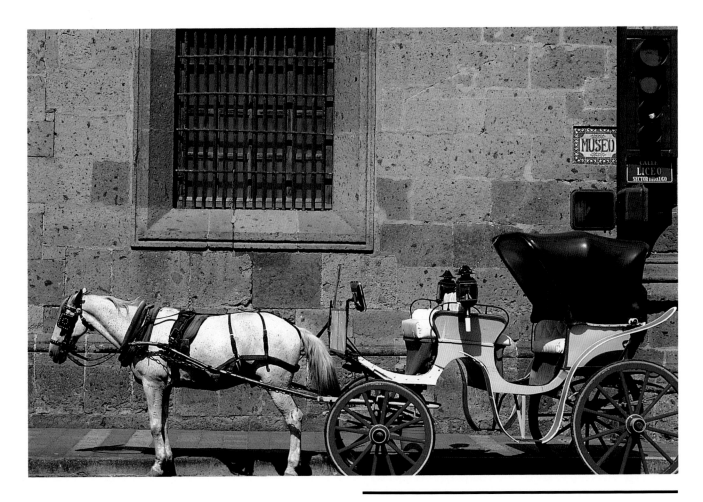

The power of yellow to draw attention is evident in this photograph of a horse and carriage taken in Guadalajara, Mexico. Even when juxtaposed against the drawing power of white in the horse, the yellow of the carriage attracts the eye. The slight telephoto effect of the 85mm lens is seen in the compactness of image size. Kodachrome 64 was used.

The rich hues that color this delivery truck stand out in late morning light against the black tar street and the gold building that provides a backdrop. The small details of the fruit stand are boxed in by the massive shapes of the truck and the building. The photograph's perspective was "flattened" by a 135mm lens set at ƒ/2.8. The idea behind the white truck with its red-and-blue logo is to be seen at a distance.

THE MEANING OF RED. Red. The word itself conjures up images of fierceness, anger, excitement, sex. It's red hot; it can be seen as aggressive and dominating. Red sizzles with energy when mixed with yellows. It was the color of Imperial Rome and of Great Britain; it is the color of sports cars, blood, and roses. Red is danger. It makes the heart beat faster: the cape of a bullfighter, the color of wine.

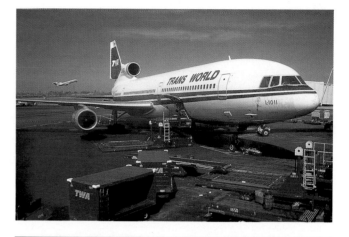

The red is hot and powerful as directional late-afternoon sunlight plays over the uneven surfaces and crevices of this red wall and doorway on Tenth Avenue in New York City to create an interesting monocolor bas-relief. The amount of intense color reflection and the shadow detail on the wall are the picture elements I chose to take advantage of and photograph with a 50mm ƒ/1 lens and Fujichrome 50. This is the color red in all its chromatic glory.

The deep industrial reds of cargo-carrying carts set against the black tarmac and the graphically designed red accents on the clean, white plane show two appearances of the same color against opposite-color backgrounds. I shot through an airport window with a 35mm lens and Fujichrome 50. This photograph exemplifies the subtleties of color vision: seeing parallel effects of the color red in the same scene. The blue sky is the balancing chromatic element.

The rain had saturated the walls—and also the colors of the paint on them—intensifying the yellow stripe and accents on the red brick. These are the two most potent "advancing" colors; they demand visual attention. I composed the image so that the yellow bar would travel through the picture slightly above the center. A 35mm lens was used with Fujichrome 50 for this shot.

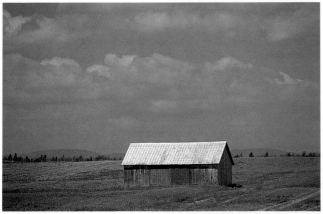

The significance of the color red as an identifying hue is graphically displayed by these barn doors in Quebec, Canada. In making the photograph, I wanted to use the barn as a small subject against a moody background, so I used a 35mm lens and Kodachrome 25. In a natural setting, the red stands alone as the dominant force.

The deep hues of Ecuadoran Indians' blankets are a study of red on red with diagonal lines. A 90mm lens was used to concentrate the viewer's eye on the weavings. The gradation of shades and the draping of the folds give a three-dimensional quality to the picture, which was shot with Fujichrome 50.

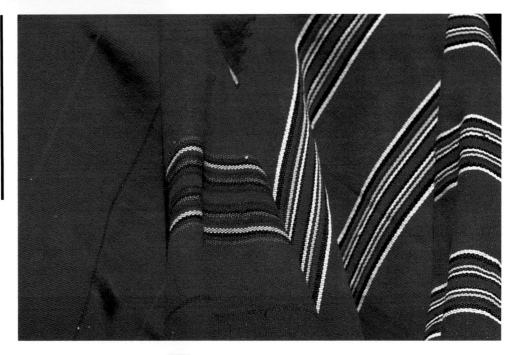

THE MEANING OF BLUE. Blue has a special place in the psyche of the Western world. It can mean royalty—people or objects that look regal. It is tranquil and self-assured. A major color, it signifies the sky, the sea—it represents the world above and around us. The reliability of blue—a police officer's uniform. The serenity of blue—the "normality" of its color temperature. It conveys stability, truth, loyalty, authority; it is no small wonder that it is used successfully in advertising to illustrate themes stressing these points.

Look at the many faces of blue here: the natural sky and the light reflected off pigments. There is a color balance in this photograph between the direct light and the light-reflective sur-faces. These beautiful murals painted on the sides of a building and its surrounding wall in Southern California were photographed on Fujichrome film with a 35mm lens.

The natural sunlight of the beach at Santa Cruz, California, animates the colors. The natural blue of the sky, the dyed blue of the canopy, the enameled whites of the molding, the neutral gray of the siding—all become parts of a visual jigsaw puzzle. The space in the viewfinder has been separated into clean, tight, geometric slices of color. A 105mm medium-telephoto-length lens was used for this straightforward angle of view, taken with Koda-chrome 64.

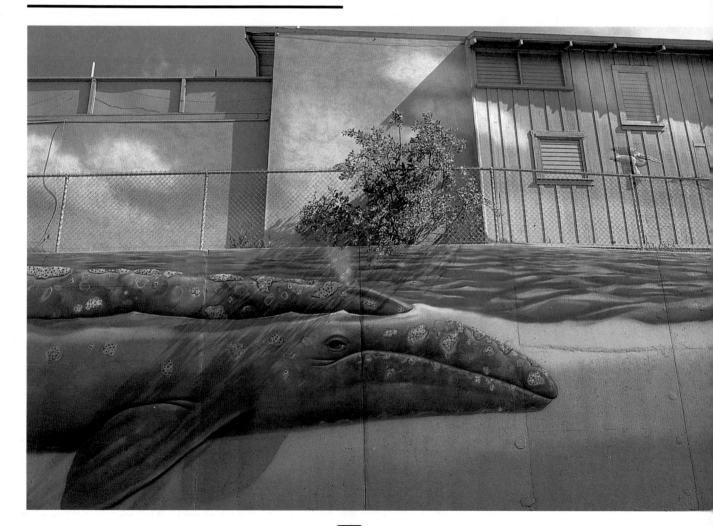

Low-light blues: early evening provided just enough light to use a 75mm lens and ISO 100 film to hand-hold a shot of this graffiti-covered metal door. The low light level and the "un-natural" colors of the spray paint make this a study in urban blues.

The contrast between the rich sky and the white and black horizontal and diagonal lines brings a fierce quality to this image of a torn billboard in Hollywood. I used Fujichrome 50, and a 90mm lens to pull the sign framework in as close as possible. The photograph reveals a selective view, where three-dimensional elements and flat surfaces influence and balance one another and are made to look as if they were in the same plane: against a deep blue sky, the stark whites of the billboard turn into a graphic outline.

The receding tendencies of the color blue are evident in this photograph of a painted plaster wall. The dark shapes anchoring the corners of the picture are abstract puzzles of color that are rich in texture. Here I used a 35mm lens and Fujichrome 100.

THE MEANING OF YELLOW. Yellow. The sun. Gold. Buttercups and canaries. The Yellow Pages. A yellow streak. Yellow hair. Lemons, corn, and bananas. A Kodak box. Yellow signifies loyalty and honor and the heat of summer . . . always advancing yellow. Taxi!

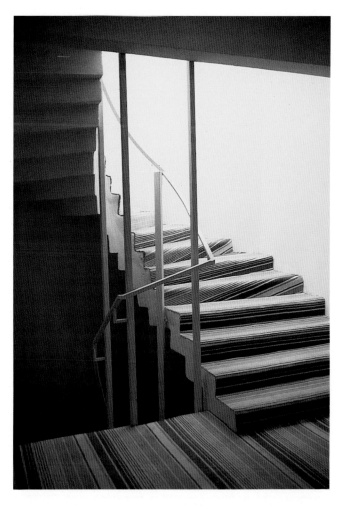

This stairway looks surreal in the light cast by a yellow skylight in the hallway of a small hotel in Turkey. Filtering out white light completely changed the color personality of the scene, turning it into a monotone. The conflicting black and yellow striped patterns of both the rug and the circular staircase add tension to the design. Here, I used a 35mm lens and a relatively slow, handheld shutter speed of 1/15 sec.

The bright yellow metal on a parked truck becomes a high-key color bar compressed optically against some discarded white-sprayed decorations. Yellow is a strong advancing color. It is the color of alertness. The stark white branches against the black of a New York City street combine with this exciting hue to make the overall color contrast abnormally high. This shot was taken at eye level with a 50mm lens.

Here, the lemon yellow of the plaster walls and the greenish yellow of the aged wooden door are striking in their chromatic vibration. The pure intensity and contrast value of the hues, saturated by slight under-exposure for effect, give the image its power. A 24mm lens was used with Fujichrome 50 for this study in aggressive color taken in a small highlands village in Guatemala.

The color of the yellow flowers, shot close in San Francisco with a 35mm wide-angle lens, advances and gives an impression of three-dimensional composition. These are flowers, but they are aggressive because of their color, as well as focus, tight cropping, and a slightly overhead angle of view. Filling the frame with closeups offers endless opportunities to work with shape, form, and color.

COMPOSITION

The interaction of comple-
mentary colors is evident in
this picture, which empha-
sizes depth of field. The
geometric design here,
with its strong diagonal
lines, was formed by both
the sunlight and shade. The
bright triangle of light in the
foreground points to the
center and dominates the
vista. The darker colors in
the background balance the
composition. The cloud for-
mation seems to be ad-
vancing because of the
perspective of a 24mm
wide-angle lens combined
with the lightness of the
clouds against the blue sky.
I used Fujichrome 50 for
this photograph, taken off a
balcony in Bermuda.

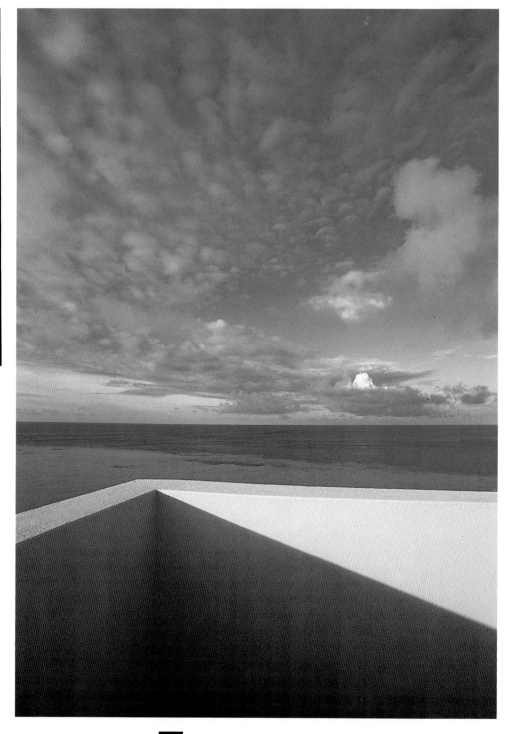

NO MATTER what type of photography is being pursued—journalistic, impressionistic, abstract, or commercial—the photographer's concept is only successful when all the elements in a photograph work together harmoniously in a balanced, well-designed composition.

There are basic guidelines for the graphic use of color in a composition, but they are, of course, open to the artistic license of the photographer. Certain colors, such as red and yellow, advance, while others, such as blue, recede. The ease or difficulty of viewing an image might depend on the contrast between the main subject and its surroundings. If the background consistently pulls attention away from the subject, the viewer will be frustrated. However, if the subject and background are in harmony, the viewer will immediately feel comfortable with the picture.

Colors at opposite ends of the "hot" and "cold" fields are contrasting extremes and create a confusing vibration when located near each other in an image. Conversely, colors next to or close to each other on a color wheel, such as red and oranges, are pleasing to the eye when placed side by side. Compositionally, objects of complementary and contrasting colors should be of different sizes or different focus. And, the deep, pure tones of saturated colors are enhanced when placed against unsaturated or pastel shades.

While few color composition rules, however, cannot be adapted or even broken, one rule should be followed when photographing in extremely bright or mixed, high-contrast situations. Because the eye always reacts to either the brightest or the whitest form in any given scene, that brightness must be made to work for the final composition to prevent its power and weight from overwhelming the rest of the picture. This can be done by balancing tones so that they are harmonious. The scene should be viewed through the lens again and again until the correct balance of shapes and forms appears.

Shape, the two-dimensional outline of an object, lacks depth but is an important element of a pictorial statement. One way to emphasize a form is to fill the frame with it, using a straight-on camera angle. It is best to aim for contrasts of color between the form and its surroundings and to position the shape against a simple background. Dark shadows and direct, definitive lighting give striking results. A silhouette is one of the most dramatic ways to emphasize shape. With the subject placed against a bright background, expose for the background; the subject will photograph black, unless the exposure is set for midway between the subject and the background.

The angle of view and choice of lens are critical in any composition in which predominant colors are arranged in definite patterns. The angle of view is the visual path chosen to illustrate an idea, and the picture unfolds from this vantage point. Each type of lens offers a different geometric interpretation of the world. A standard 50mm lens has a perspective similar to that of the human eye (which can focus on about 46 degrees of any scene), while a wide-angle lens includes more of a scene but renders it smaller. A telephoto lens, on the other hand, crops out most of the same scene and renders what is left larger than normal.

Finally, a horizontal or vertical format, depth of field, directional lines, and focal points are responsible for leading the viewer's eye to the most important area in a picture: the center of interest. Unless the eye is able to find such a spot, rest there for a moment, and absorb the artist's intent, the meaning of the picture will be lost.

With a secure, yet adventurous, attitude about composition, a photographer can both write and creatively design with light.

Several coats of green paint on this old house had worn away into fragments. The color personality of the building, with its greens, browns, and black doorway, balances the cloud-decked blue sky. The recurrence and position of the greens carry a strong color signal. Shooting in Bermuda, I used a 50mm lens.

A certain feeling of movement is found in this shot of clouds and a white building taken in Oaxaca, Mexico. The slant of the 24mm lens used has created an illusion of expanse in this vertical composition. The yellow ochre window and the brown door against the whites of the house and clouds are balanced by the blue above.

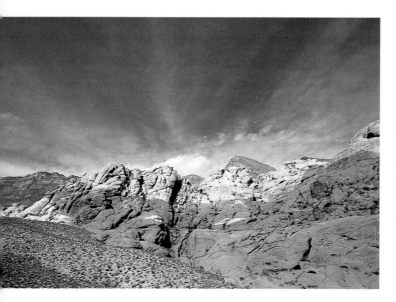

A tight telephoto shot of Red Rock Canyon, Nevada, is composed around blocks of color. The jagged shapes and textures of the rocks balance the blues and whites of the sky. When the viewing angle changes, so do the relationships among, as well as the relative sizes of, the elements in this photograph, taken with a tele-zoom lens. Close and low angles of view expand the perspective, whereas distant viewpoints lessen the effect.

Taken from approximately the same working distance as the photograph above on the left, this shot expands the viewer's feeling of depth because of the low angle of view and because of the 19mm super-wide-angle lens. The short focal length provides almost a new composition. The basic formula of the three color bars applies here, but the value of the colors in the composition has been drastically altered.

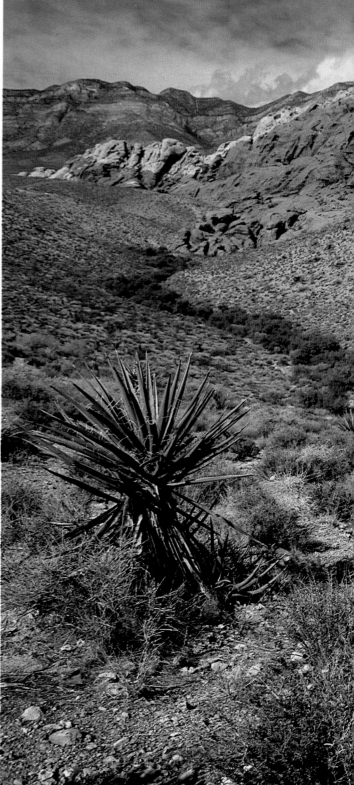

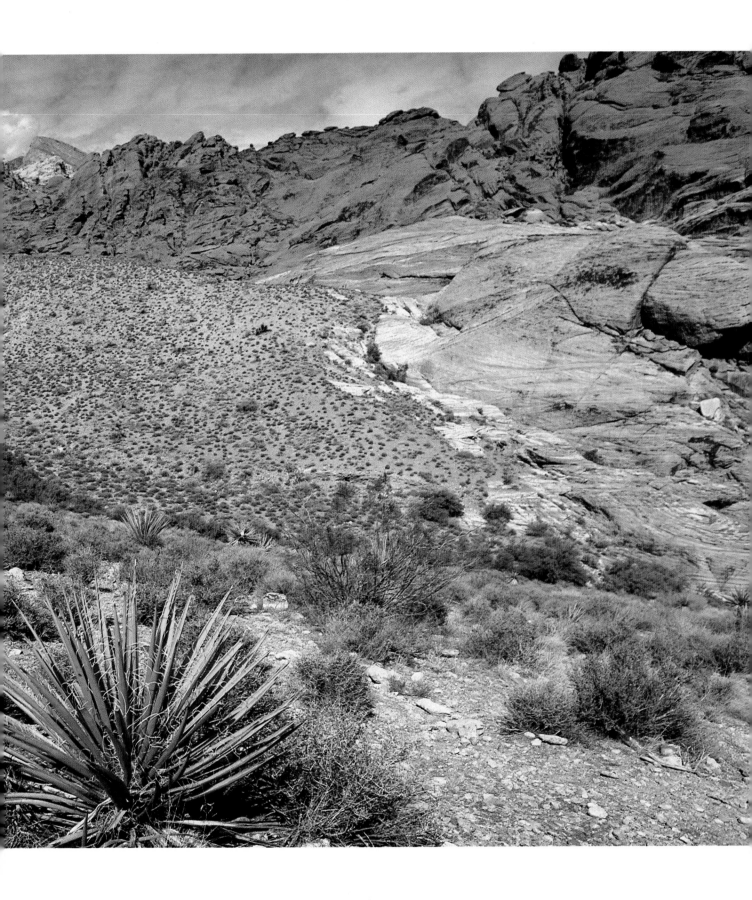

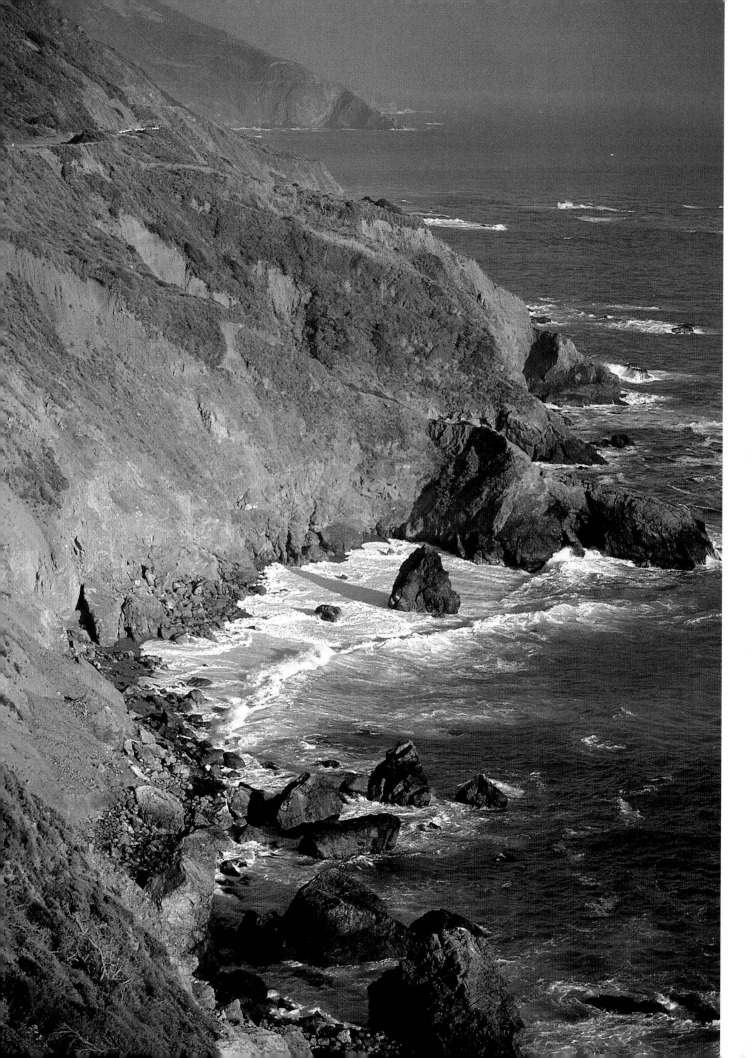

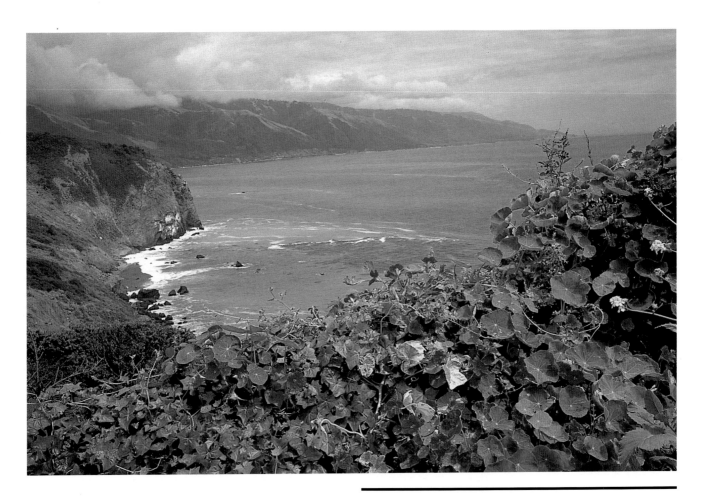

Harmonious conformity of shapes and of colors is the strength of the quiet composition of this image, taken with a 35mm lens. The natural curve of the California coastline is balanced by the diagonals of flowers and shrubs. The feeling of space is conveyed by the brighter colors and details in the foreground, as well as by the cooler, soft colors of the coastline and sea in the background. Adding to this depth is the gentle sweep of the curve in the upper third of the image.

The S curve is obvious in this ultra-wide-angle view of a cove, taken in Bermuda with a 15mm lens. The curve was used as a framing element to split the picture into three shapes: the ochre-colored cove, the sky, and the sea (as a horizon line). The eye follows designs where such a curve, or a strong abstract shape, divides the picture. The foreground detail of the cove makes the apparent space between it and the horizon seem immense.

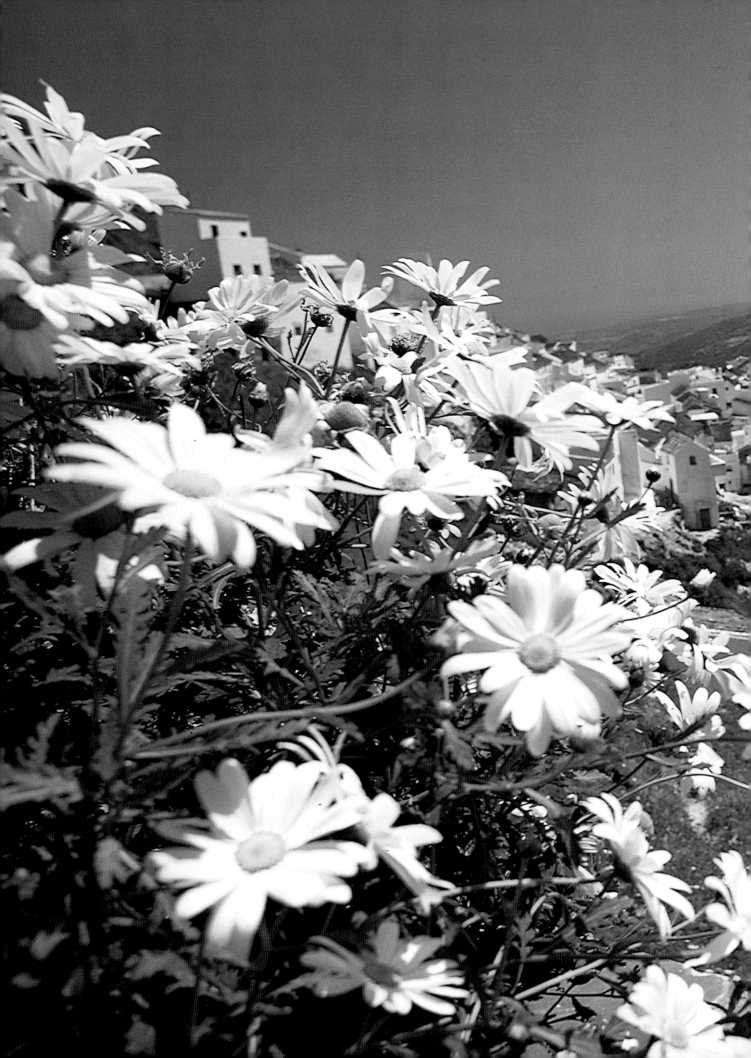

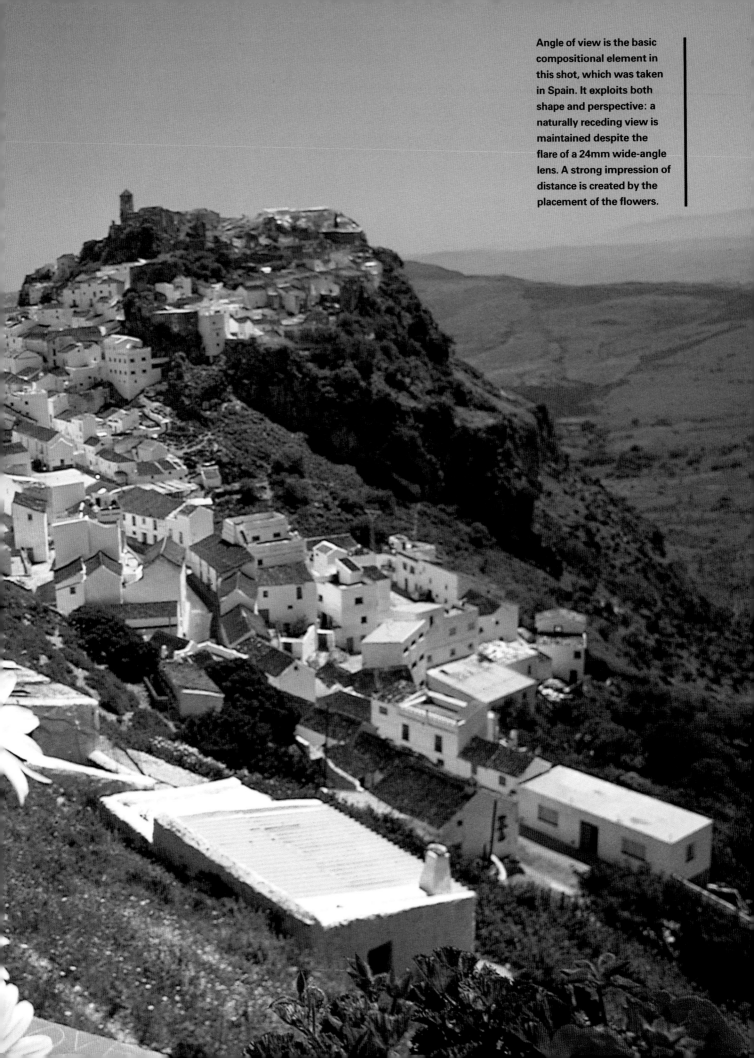

Angle of view is the basic compositional element in this shot, which was taken in Spain. It exploits both shape and perspective: a naturally receding view is maintained despite the flare of a 24mm wide-angle lens. A strong impression of distance is created by the placement of the flowers.

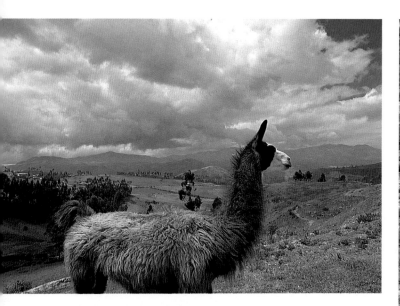

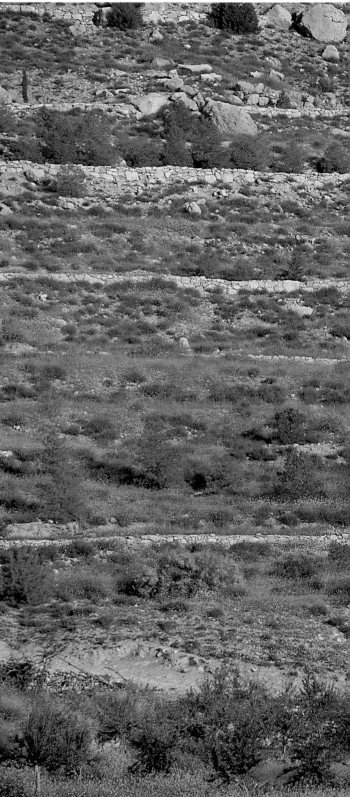

Perspective looks natural here even though a 21mm extreme-wide-angle lens was used. The brown tones of the llama and the green earth, blue mountains, and clouded sky endow this picture, shot in Ecuador, with a feeling of space. The sense of distance is emphasized by the sharpness and texture of the llama, whose shape stretches across the frame, while the depth of focus remains intact into the distance. Extreme depth-of-field is part of the composition.

The terraced hill, with its strong horizontal lines, makes a strong subject for the stacking effect of a telephoto composition. The lines that run across the frame intensify the feeling of compressed space: the man and his horse entering the picture in the lower right corner are facing a long journey across the frame. The earth tones in the background give the picture, taken in Jordan with a 180mm lens, a sense of order, and the directional lighting helps bring out texture.

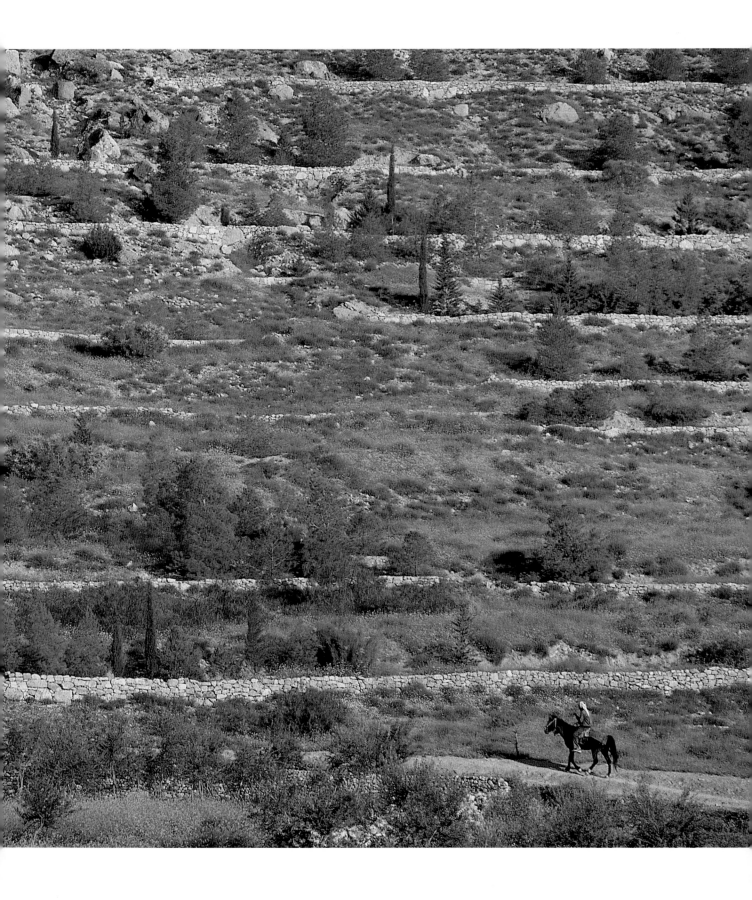

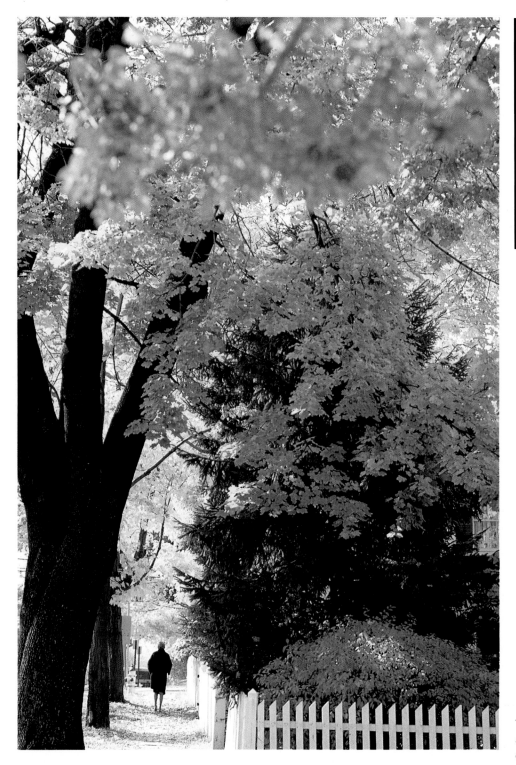

The woman has been placed in the lower left corner of the frame, and the whole photograph seems to engulf her. The trees and shrubs have been used as a framing device for this image, taken in Pennsylvania. The medium-telephoto effect of my 80mm lens flattens the perspective. The red foliage at the top and the white fence at the bottom counterbalance each other.

To add proportion, depth, and containment, a framing device of jungle growth was used as a design element in this wide-angle photograph of a Central American pyramid, taken in Tikal, Guatemala, with a 24mm lens. The black shapes in the foreground balance the blue sky and the monument in the distance.

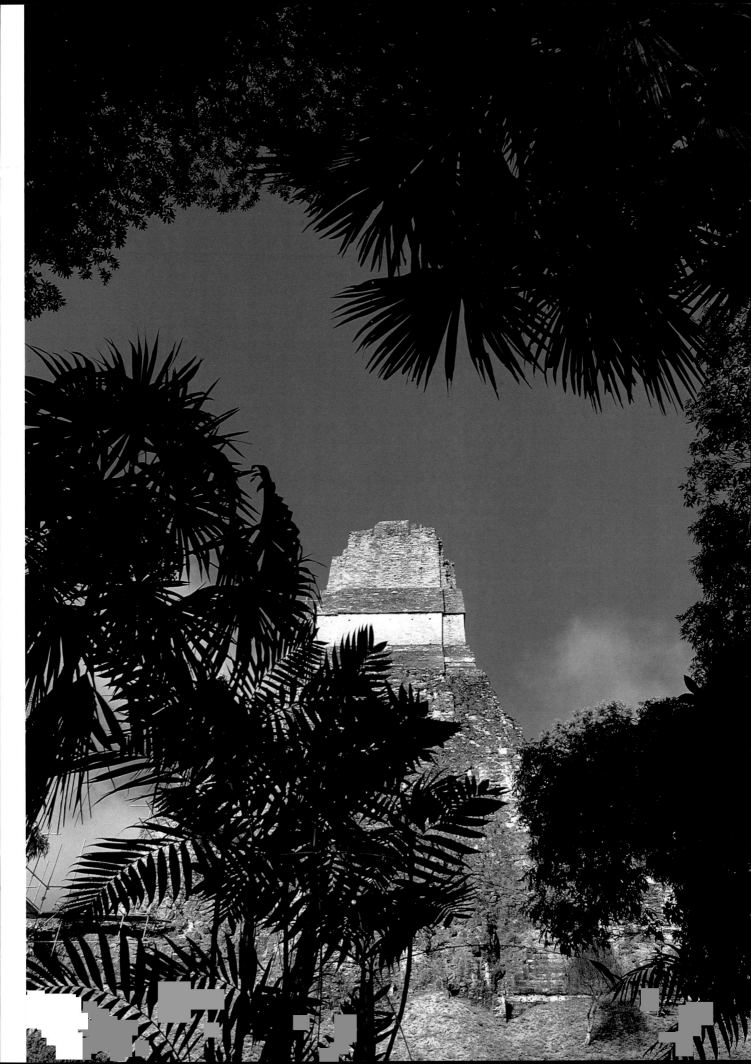

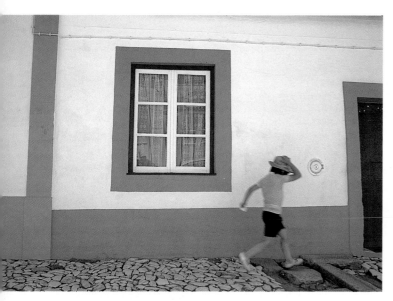

The composition has been set, and a moving form runs across the image. The balance of color and shape makes it possible for the boy to be the center of interest of this picture, which I shot in Portugal with an 85mm lens. Space is emphasized by leaving an area for the boy to run into.

The composition had been predetermined, being divided into thirds, when the family opened the door at the creative instant. The colors are cool, and the people are advancing toward the camera, which produces a feeling of immediacy. I photographed this scene in Rhodes, Greece, and used a 105mm lens.

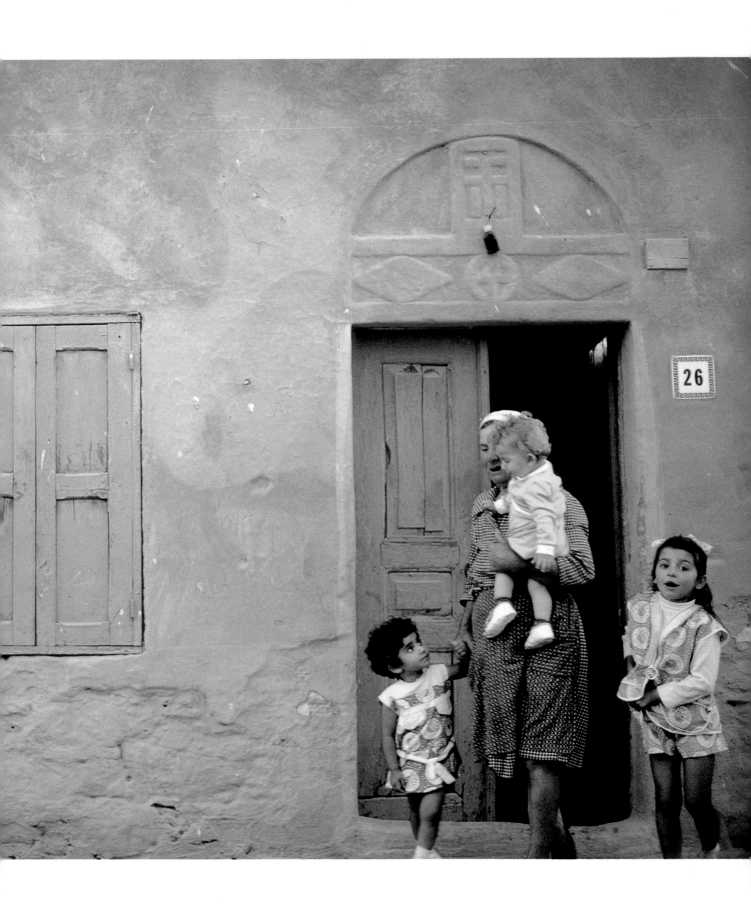

D.

N.

J.C. TRUCK
EQUIPMENT INC.
THE COMPLETE TRUCK EQUIPMENT PLANT
GARDEN CITY PARK, L.I. N.Y.

Serial No.

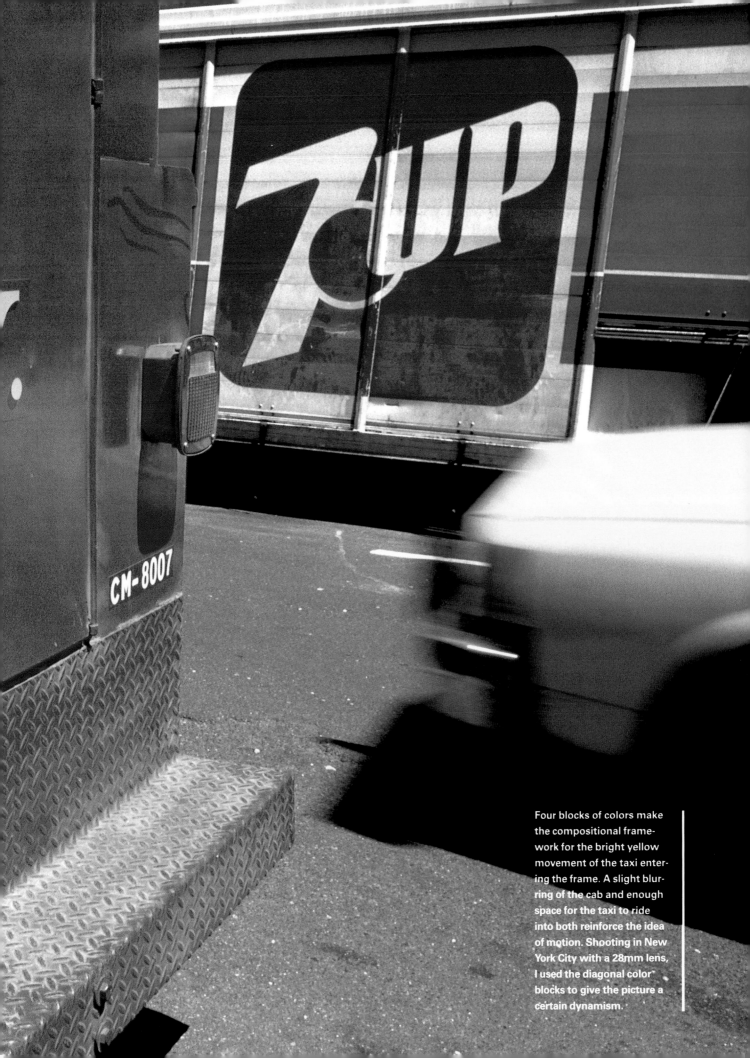

Four blocks of colors make the compositional framework for the bright yellow movement of the taxi entering the frame. A slight blurring of the cab and enough space for the taxi to ride into both reinforce the idea of motion. Shooting in New York City with a 28mm lens, I used the diagonal color blocks to give the picture a certain dynamism.

Both the blue wall and pole are bright from the sun, but the yellow vertical, placed off-center, stands out even against the black shadow.

Shooting in New York City and using a 50mm lens, I composed the whole picture with regard to vertical and horizontal shapes.

This two-color composition of line, shape, and shadow proves that shadows can add depth and can be used to create a three-dimensional feeling, even in a seemingly static composition. Intersecting color lines are the visible framework of the design of this image, which I shot in Gettysburg, Pennsylvania, with a 90mm lens.

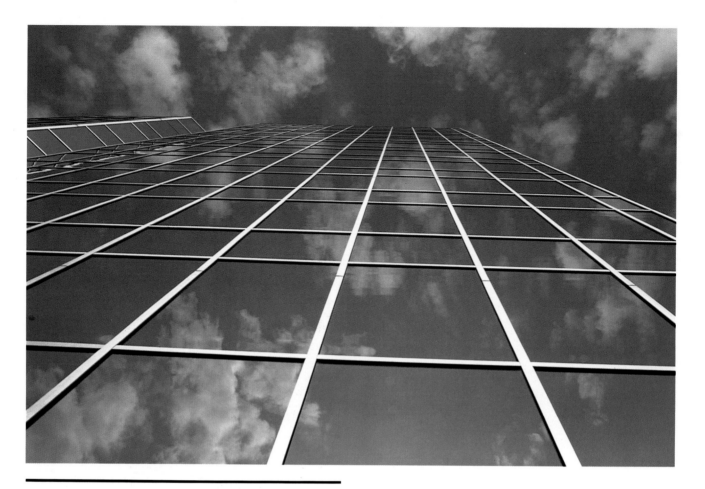

The intense angle of view of this triangular composition, photographed with a 28mm lens, gives dynamic perspective to the reflection of sky and the converging lines of the building. Upward lines giving the impression of movement away from the viewer can be an exalting experience. Here, the base of the triangle provides a sense of strength because the lines are leading toward a predetermined point.

Colors, forms, and shapes that repeat themselves often make good subjects when the angle of view makes the most of the patterns, as in this compressed view of a repetitive pattern set within a composition of intersecting lines. Pulling in detail with a 180mm telephoto lens made a thematic design of this building, which I came across in New Jersey.

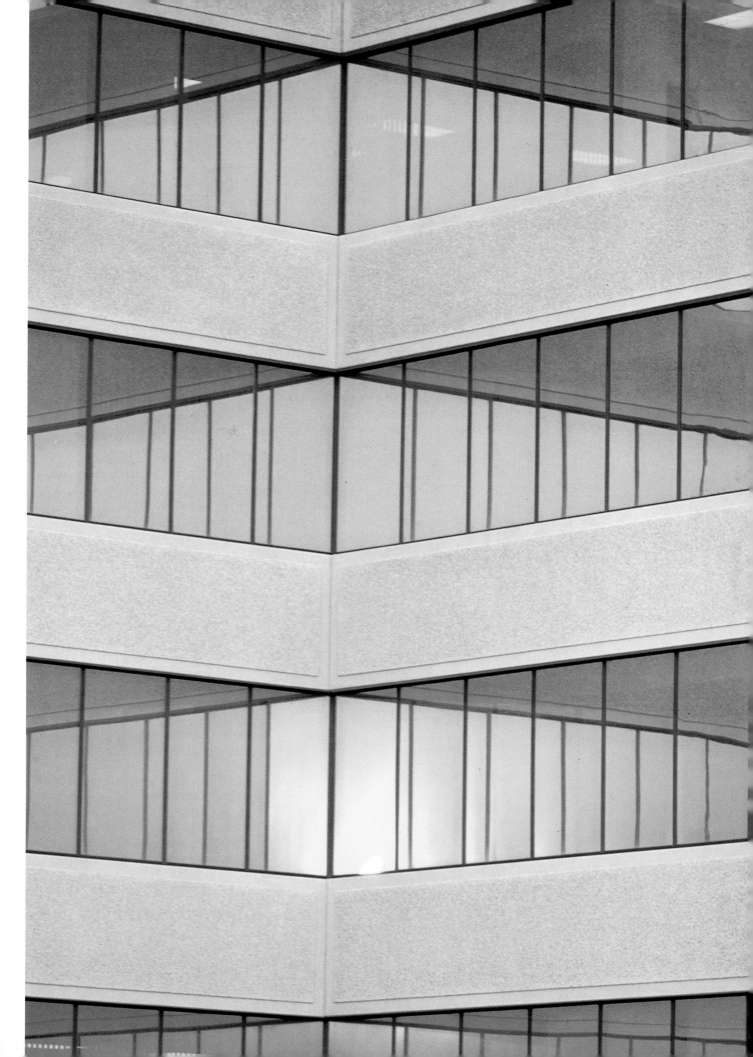

AN ASPECT OF SHAPE, line adds depth or tension to a composition. Bold lines create interest by producing unusual divisions within the frame, as do lines that interact strongly with one another. Converging lines sometimes create abstractions. A sense of motion results when lines "run" across an image photographed from an angled perspective. This is particularly true for closeups. Strong lines are brought out by stark, flat lighting. A good way to direct the viewer's eye, lines give visual cues about what the photographer considers important.

This geometric composition deliberately uses color and lines as a statement of harmony. Four blocks of color were included, along with the vertical of the red post. Bright, directional sunlight shows off the wall's texture. I shot this scene in California with a 90mm lens.

For this geometric composition, I divided the picture space into three vertical blocks of color. However, the resulting horizontal blocks in the top right and the bottom right, created by shadow and color respectively, also serve to balance this image.

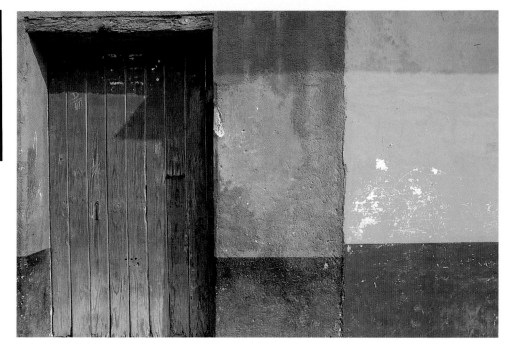

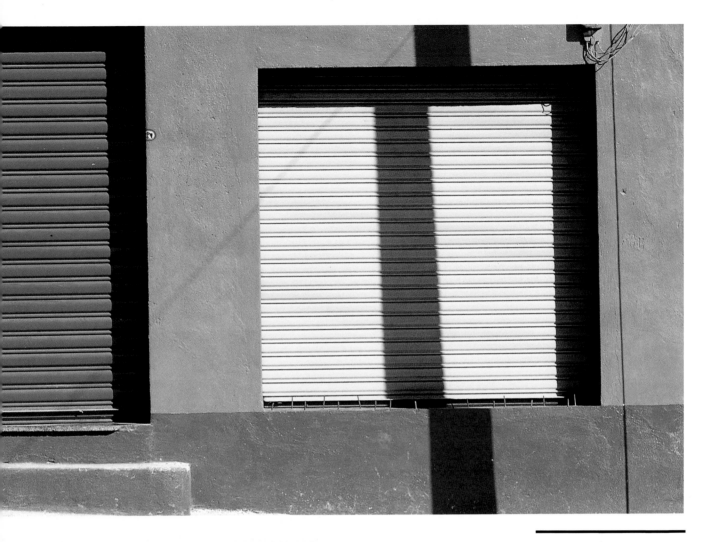

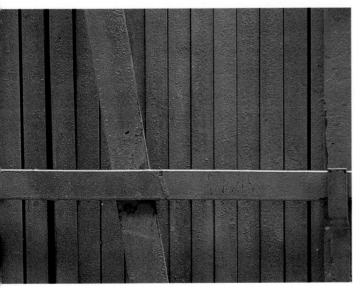

In this New York City landscape, the striking hot pink color of the storefront gate was an unusual find that lent itself to any number of geometric compositions. For this one, I used a 75mm lens to break up the space into a design of horizontal, vertical, and diagonal lines. The lighting—overcast daylight—emphasized the color punch of the painted metal bars. A monochromatic composition must be special not only in hue and lighting but also in the overall design concept.

Color shapes that are complementary in color value are used along with geometric shapes and shadows to break up the space in this picture. Intersecting lines work with the colors and shapes to make a strong statement about space and form. I photographed this image in Guatemala, using a 100mm lens.

ABSTRACT COLOR

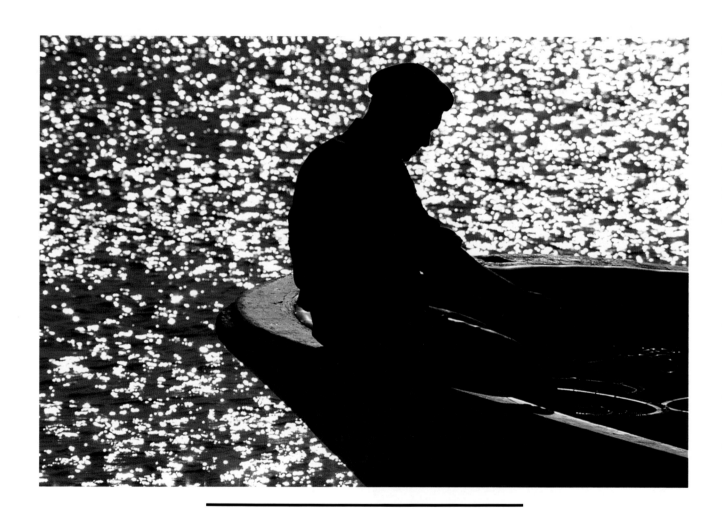

For this dramatic photograph of a man fishing in Portugal, I used the bright highlights and black silhouette to break up the space and to create a detailed study of specular highlights in the water. There is actually no color on "color film," and "light" is an abstraction—and so this easily recognizable image is in fact impossible to see with the naked eye. The result is an abstract exploration of light and color. I shot with Kodachrome film and a 400mm lens.

IN THE MIDDLE of the nineteenth century, French painters decided to defy the normal visual perception of any given scene and create a new reality of light and color that would show, for the first time, the entire color spectrum of a scene as a dazzling whole. Also, viewers played a part in this experience by visually mixing the colors. This way of presenting their impressions of color and "feeling"—the emotional thrust of the painting—was revolutionary. In today's new age of technological prowess and of the primacy of visual rather than verbal communication, advances in color-film emulsions and in high-technology special coatings for the new lenses, a new age of color awareness is also coming into its own—but now the canvas is film and the art is photography.

Like Modernist painting, abstract color photography works in a world of fragments. The color photographer's goal is to envision a new reality of light and color and transfer this vision to film. These abstract explorations of light and color are represented on a two-dimensional plane in a picture in which identifiable reality has been reorganized so as to stimulate a new visual perception. In this type of photography, subjects are chosen for their usefulness to the color composition and the division of space—what I call "pictorial autonomy" of the subject. In its still-life version, this type of photography can reveal unnoticed details and nuances of our everyday color environment. When I look for subjects for this kind of photograph—a pictorial composition in which the photographer does not set a scene but reacts to events and settings as they present themselves—I choose a theme in which the shape, texture, lighting, and color of an object or scene elicit an emotional reaction.

Abstractions are photographs of objects that others have looked at but have never actually seen. A red wall behind a blue and white fire hydrant on a busy corner might seem ordinary to others, but you might be the one to see the abstract color possibilities in this scene.

Color in disarray is abstract color. It is intrusive color, even color of assault, colors that do not seem to relate to each other. Color does not always please and soothe. It can shock, making the viewer look at and think about the subject. What makes abstract color striking, in large part, is its framing. This reveals what the photographer thinks is most important in a scene. One of the most critical suggestions for abstract photography is to keep the camera up to your eye, always, and keep moving until a scene appears in proper balance.

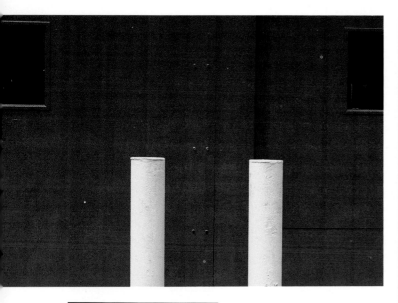

The advancing color of the yellow stands out on an overcast day, when the lighting is flat—equal on foreground and background. The focus in this abstract image, taken with a 75mm lens in New York City, is on the yellow vertical posts, which divide the composition roughly into thirds. The black windows strengthen the composition by anchoring each side of the picture.

This photograph, taken in New York City with a 35mm lens represents "color vision" in its purest form: an entire wall of deep aqua, blue, and red, a mixture of paint and posters ripped and worn into many odd shapes, is the color reality that presents itself. The photo-design process starts at the point when the photographer isolates a small section from which to make a new abstract color design. This particular image exploits the visual problem of focusing simultaneously on the large areas of red and blue. The division of space in the picture heightens the tension between them.

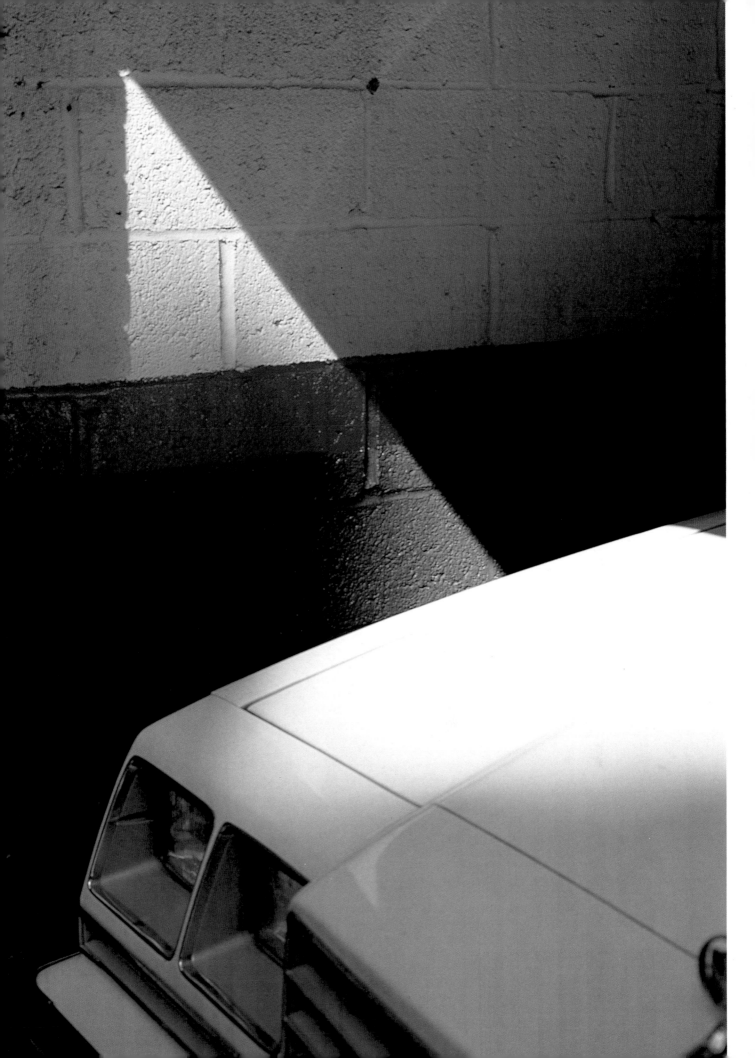

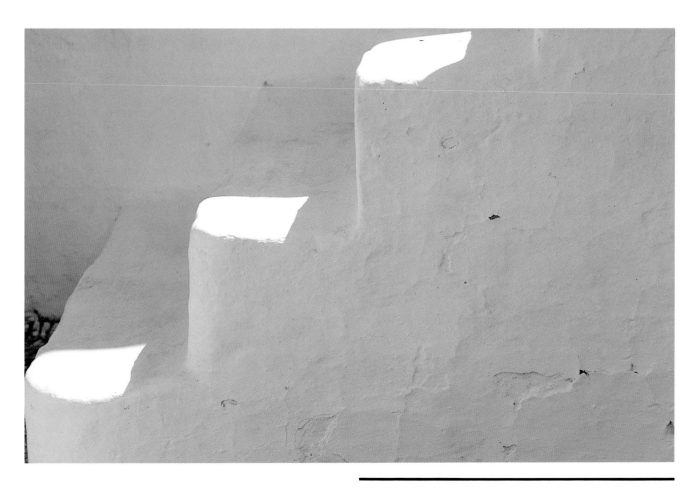

The use of space and light as design elements can be seen in this abstract composition of white steps in bright sunlight. The diagonal position of the three white shapes commands attention: they are eye-directors of white light. Imaginary lines dividing the frame vertically and horizontally in thirds show why the white shapes were placed where they were. I shot this image in Spain with a 50mm lens.

Light is the main theme of this photograph of a car in a New York City garage. Because of the extremely low light, I had to use a 50mm superfast lens to capture the light's pattern on the wall as well as the high reflectance of the white car. The result is an abstract study of light: a piece of car, a slice of light, a part of a wall. Low-level lighting has its own color atmosphere: indirect light, muted tones, and visibility of details in the shadows.

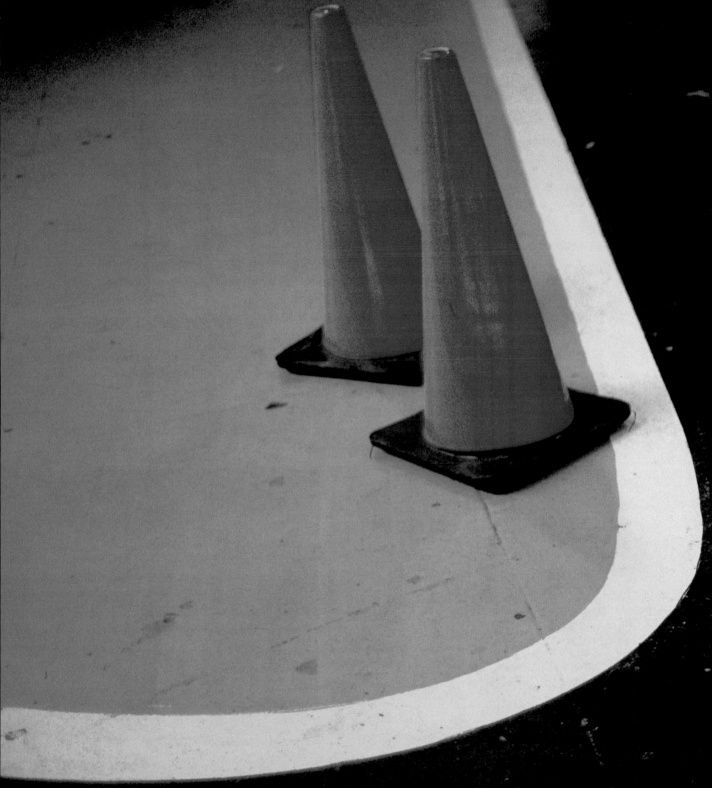

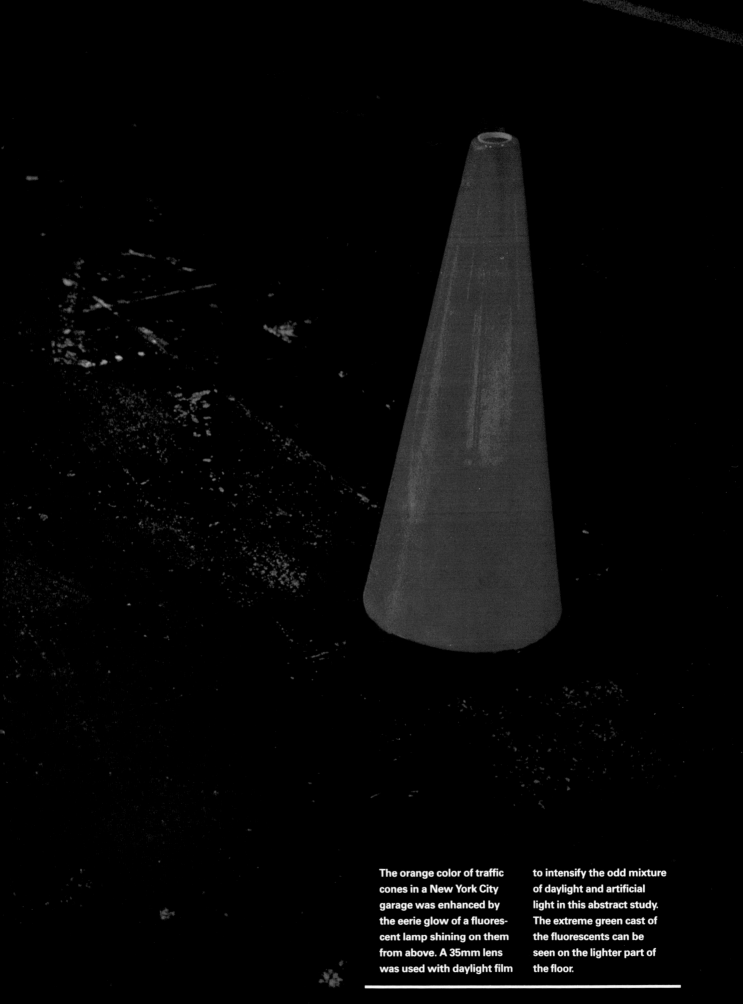

The orange color of traffic cones in a New York City garage was enhanced by the eerie glow of a fluorescent lamp shining on them from above. A 35mm lens was used with daylight film to intensify the odd mixture of daylight and artificial light in this abstract study. The extreme green cast of the fluorescents can be seen on the lighter part of the floor.

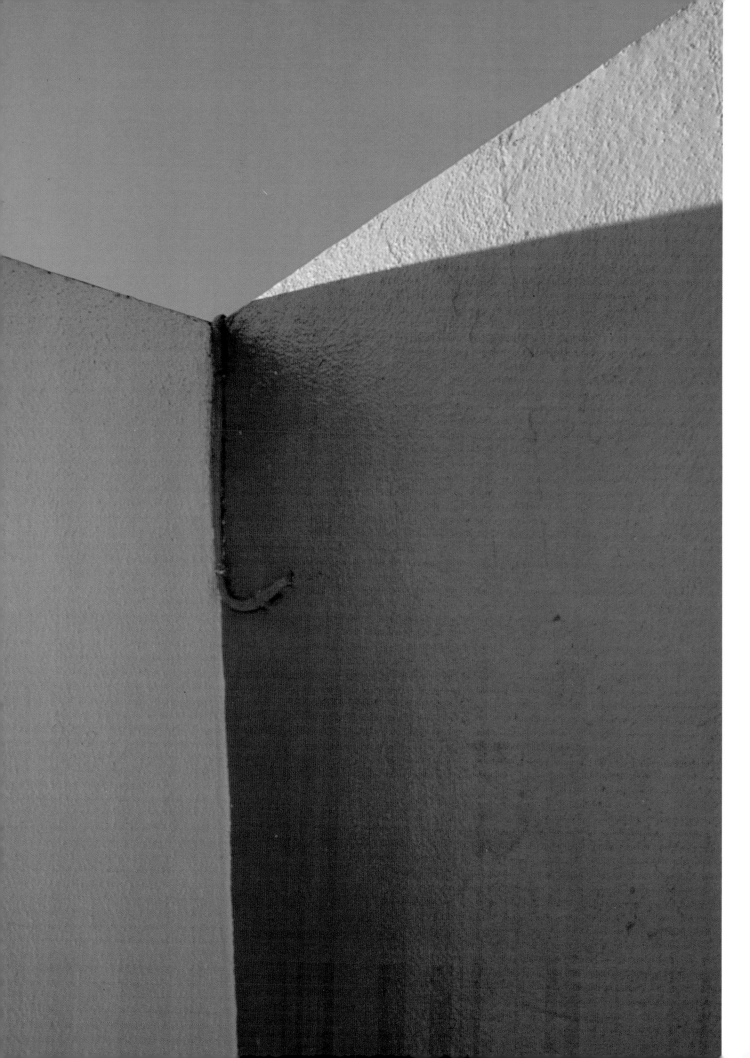

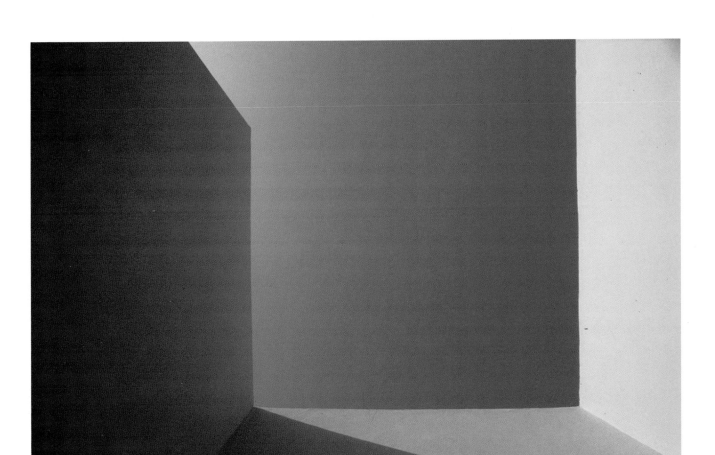

Light is the subject of this image. The abstract shape of the bright blue sky is balanced by the two pink tones: the bright sunlit pink and the pink in the open shade. The change of color value between direct sunshine and shadow illumination is evident. The straight-upward angle of view in this picture, taken in Boca Raton, Florida, with a 19mm lens, adds a dimension of openness to the blue sky.

A geometric design with strong diagonal lines is composed with both sunlight and shade. There are four abstract blocks of color, including the blue sky, but the light purple triangle is the main thrust of color and design of this shot, taken with a 90mm lens in California. Use of a short telephoto lens to produce tight cropping was essential to the composition.

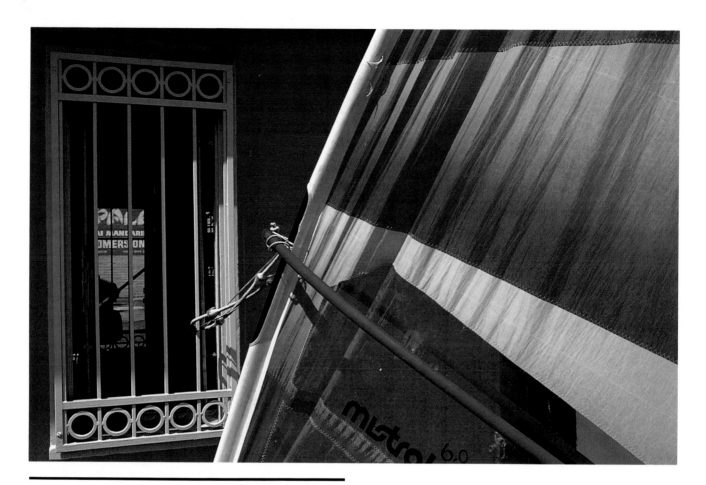

The glowing paint of the building showing through the clear plastic window of the side-lighted sail heightens the color tension in this Southern California setting. Photographed with a 35mm lens, the dynamic angle of the sail and the white out-line of the window intensify the foreground-background contrasts: viewers are forced to see space and color instantaneously on the two-dimensional plane of the picture's surface; that is, to see this abstract scene as a whole.

The strong afternoon light drenches this abstract study of a wind-surfing sail, shot in Southern California with a 35mm lens. I wanted to compose these angular blocks of color into a picture puzzle. This is an example of "pictorial autonomy": the object photographed is now defined only by its color and its placement in the composition.

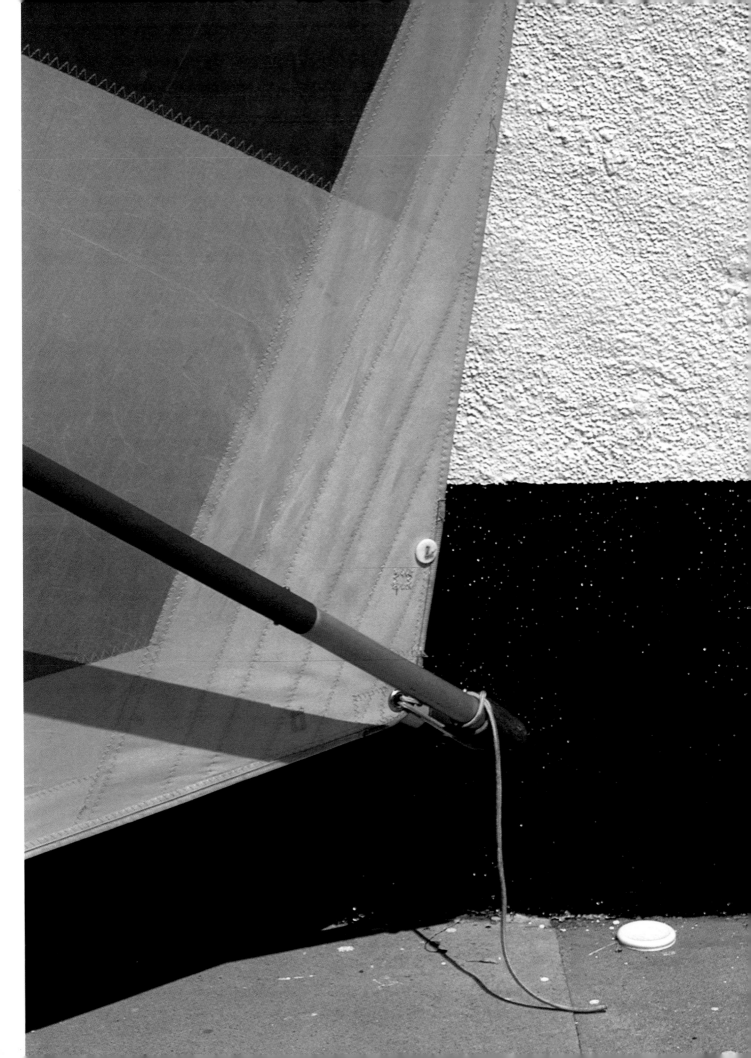

THE ART OF ABSTRACT photography begins the moment the photographer finds an aesthetically interesting subject and decides to translate this image onto film. If the photographer decides to work with colors in terms of geometric design, contrast extremes, or unusual angles of view, striking images of abstract color can result.

The photographer seizes a scene filled with abstract color, seeing it as a whole. In a way, every picture is an abstract—a part of reality chosen to be photographed—but the true abstraction is tighter, more cropped, and innovative. Color shapes and forms become tools.

Photographing in New York City, I came upon a brightly colored commuter bus. I used a 90mm lens for this closeup, which is an abstract study in red, blue, and white. The image was composed carefully: the large areas of red on top balance the white and blue lines in the lower part of the picture.

I came across these guns resting on the board of prizes at a fair in Quito, Ecuador. Using a 90mm lens, I wanted to get a tight crop in order to make this an abstract study in chromatic color on an overcast day. "Vibration" is its theme. The apparent motion of color within it is an illusion caused by the problems the eye has in discerning which color to focus on first.

Color by design: the bright colors were broken into four rectangular shapes and spaced across the frame. This type of abstract color barrage assaults the viewer with a two-dimensional impact. The horizontal bars of various widths and intersecting vertical lines running across the picture provide psychological as well as compositional stability. I used an 80mm lens to shoot this typically Mexican blanket.

Color shock was my purpose in this abstract image, shot in Ecuador with a 90mm lens. The colors are in conflict; it is hard to focus the eye or to find a single dominant color. The hues are saturated, aggressive, and piled together, making the tension level high.

LOCAL COLOR

An ambience of gold reflected the feeling of the Orient in this photograph of a floating restaurant in Hong Kong, shot with a 35mm lens. The imposing shapes of the dragons in the early-evening light added an air of mystery to the scene, as did the woman walking away from the camera. Here, the color environment is the photographic message.

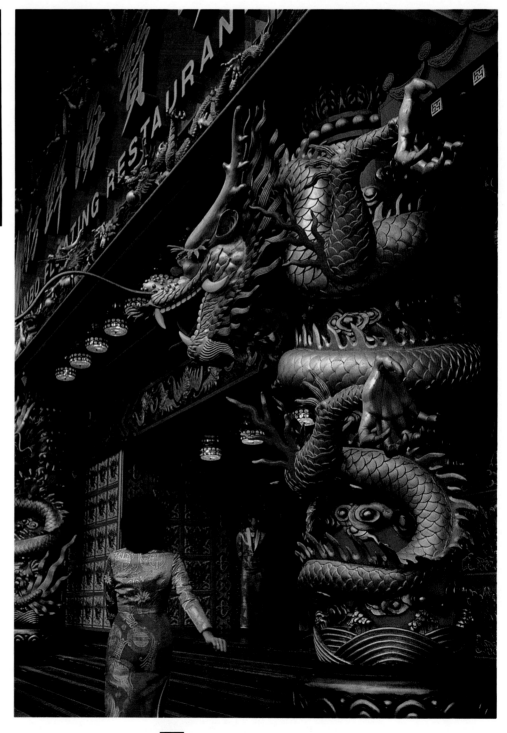

ONE OF THE MOST difficult assignments a photographer can have is to try to capture the feeling or essence of a locale, recording a visual facsimile that excites the viewer and conveys a true visual presence. After arriving at a location, the photographer must become acquainted with the environment, absorb it, and then try to photograph appropriate symbols of the place—the shot that tells all.

This type of shooting, photography in the field, has been described as "planned luck." A photographer needs to be in the right place at the right time, supported by careful planning, technical skills, and an aesthetic vision.

Desert lighting has its own special difficulties. The generally open skies, bright sand, and rock give high levels of illumination that can cause visual confusion: it is hard to view a scene that is as intensely bright as the desert at midday, when white light is at its highest reflectance level—it can be literally blinding. To help compensate for extraordinary visual circumstances, make frequent and careful incident-light readings.

The light in the desert is fleeting and harsh, and great care must be taken to look for the most favorable times and conditions to take photographs that capture the color of the scene. For instance, heat haze over long distances can lower contrast, producing even-toned and somewhat dull images; and over hot sand there can be visible distortions of the air. Haze is more of a problem in the middle of the day, when the sun is directly overhead. Textures and shapes are rendered poorly, and this makes the desert appear formless and devoid of color. Telephoto lenses cause problems of their own, but a polarizing screen or an ultraviolet filter can improve color saturation and increase tonal range.

A tip to the wise: sunrise and sunset are the times to render the desert in its most spec-tacular beauty. Then, the sweeping light high-lights the shapes and surfaces of sand and bare rock, emphasizing textures.

Since photographing in the mountains generally involves great distances, and because there is less atmospheric screening at high altitudes, ultraviolet light is very pronounced.

To avoid a strong blue cast, or overtone, in the color photograph, it is advisable to use an ultraviolet filter. Also, the use of a polarizing filter can help cut down reflections and haze and add punch to some scenes that otherwise appear washed out or diluted; polarizers improve color saturation and apparent contrast.

The jungle and the tropical rain forest are lush, green, and unforgiving. The density of the vegetation creates a monotone of green. The little light that streaks through the plant growth and illuminates the area is a hazy beam of weak white light that acts like a spotlight.

The rain forest and the jungle are ideal places for using fast wide-angle lenses. The closeness of the encroaching vegetation, the almost nonexistent light, the photographer's inability to focus precisely in the darkness, and the need for great depth of field all make the use of this type of lens a requirement.

Fast films are also a necessity when hand-held photography is being done. Such films as Kodachrome 64, and Fujichrome 100 and 400 seem to be best for these low-light, excessively green situations. They are designed for use where shadow detail is essential. Filters to protect the front element of the lens from humidity and foreign particles are recommended. An ultraviolet (UV) filter or a skylight filter should be on all lenses at all times. Because of the overall "greenness" of the rain forest, it is advisable to use light amber filters to counter the green cast that can influence the color rendering of the final result on the film. A small, lightweight tripod is also indispensable.

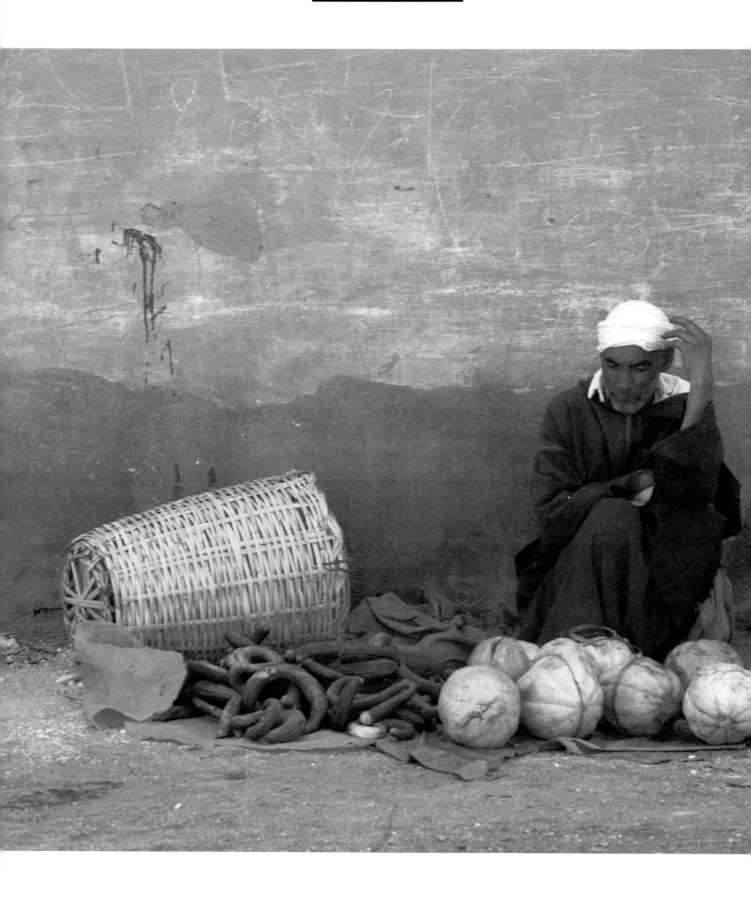

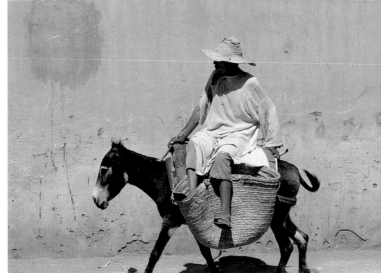

The white afternoon light of North Africa mixed with the dusty surroundings to diffuse the earthy colors of the main subject. I used a 135mm lens and waited for the man on his donkey to enter the scene. I then balanced the light colors of the wall with the dark shadow on the ground.

Shooting with a 105mm telephoto lens and Ektachrome and standing in the shade, I photographed this fruit vendor in Marrakech. The muted tones of the scene mixed with ambient light to give a soft, almost timeless look to the man and his wares. A photograph that encompasses the right color and subject can communicate an eternal theme.

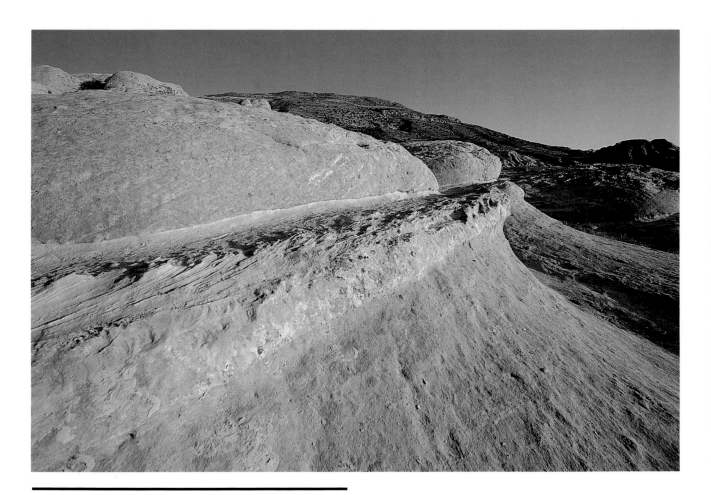

In the last light of day in the Jordan desert, I photographed this interesting rock striation with an 18mm wide-angle lens to convey the vastness of the space between the viewer and the horizon. The texture of the rocks was picked up by the sidelight, which was faint and warm but still able to render surface quality. I used the lens very close to the foreground rock in order to add a sweeping perspective: this illustrates the principle of including the immediate foreground as an integral part of the "live" area of the picture.

The exaggerated perspective of this shot was caused by a 24mm wide-angle lens, used to emphasize the dramatic difference between the vastness of the carved rock and the smallness of the man sitting on the steps. An upward angle conveyed a feeling of the soaring heights of the so-called Treasury building in the ruins of Petra in Jordan. The rose-colored structure was further enhanced by the bright, early-morning desert light, which was harsh and cast deep shadows that mold textural detail.

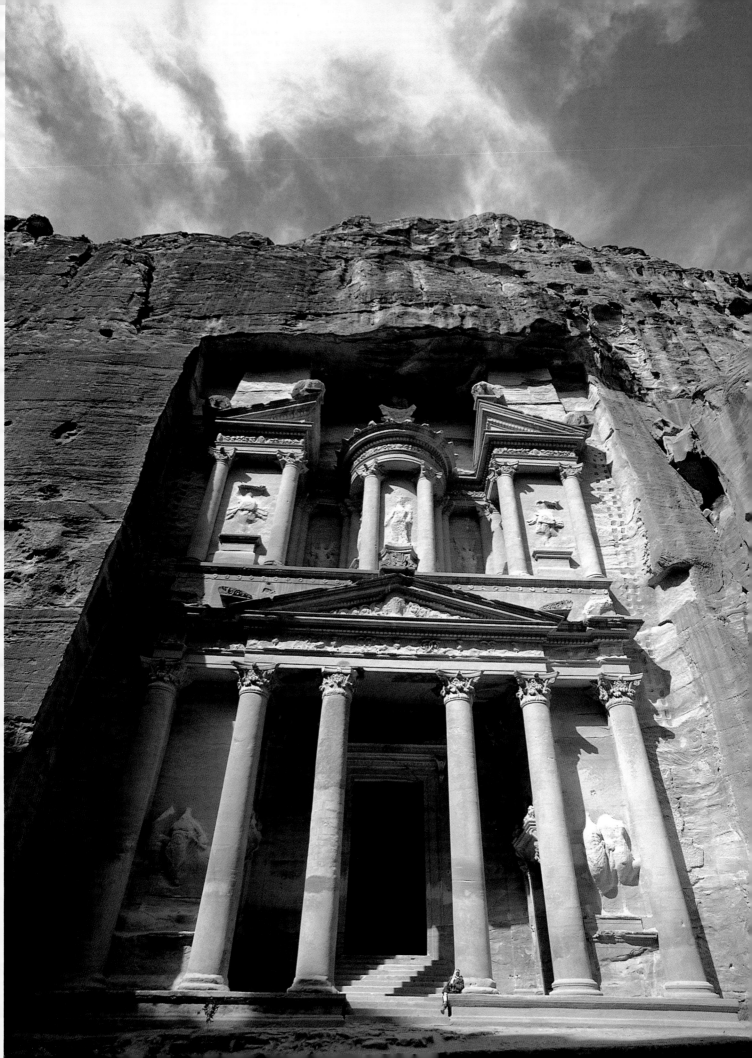

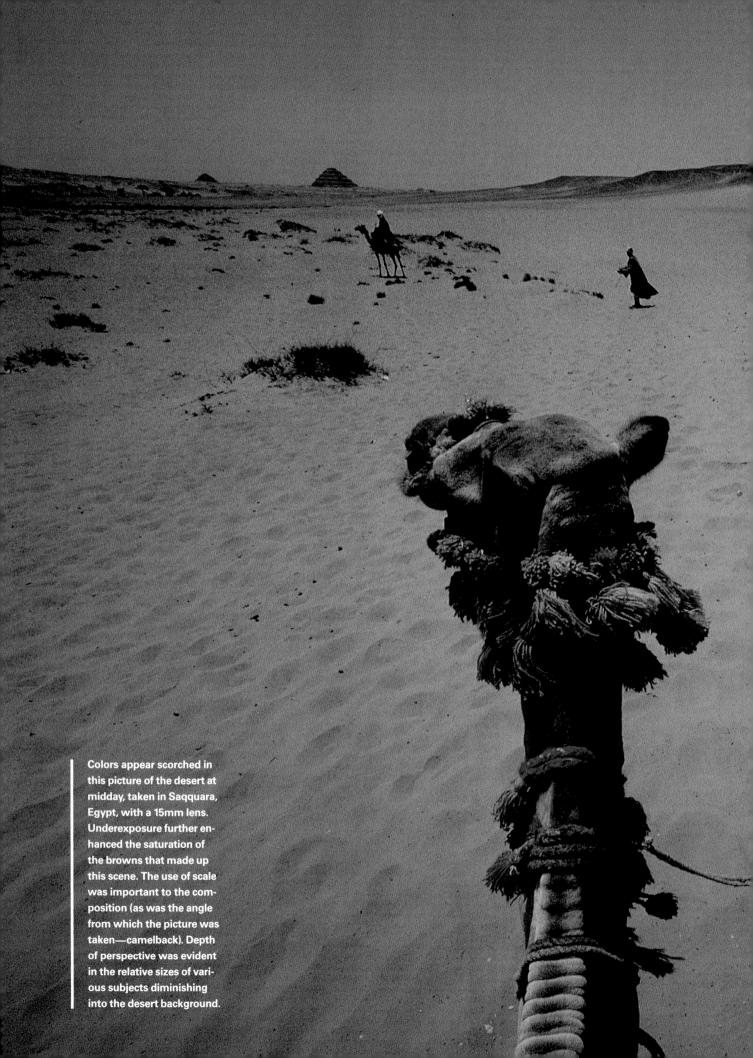

Colors appear scorched in this picture of the desert at midday, taken in Saqquara, Egypt, with a 15mm lens. Underexposure further enhanced the saturation of the browns that made up this scene. The use of scale was important to the composition (as was the angle from which the picture was taken—camelback). Depth of perspective was evident in the relative sizes of various subjects diminishing into the desert background.

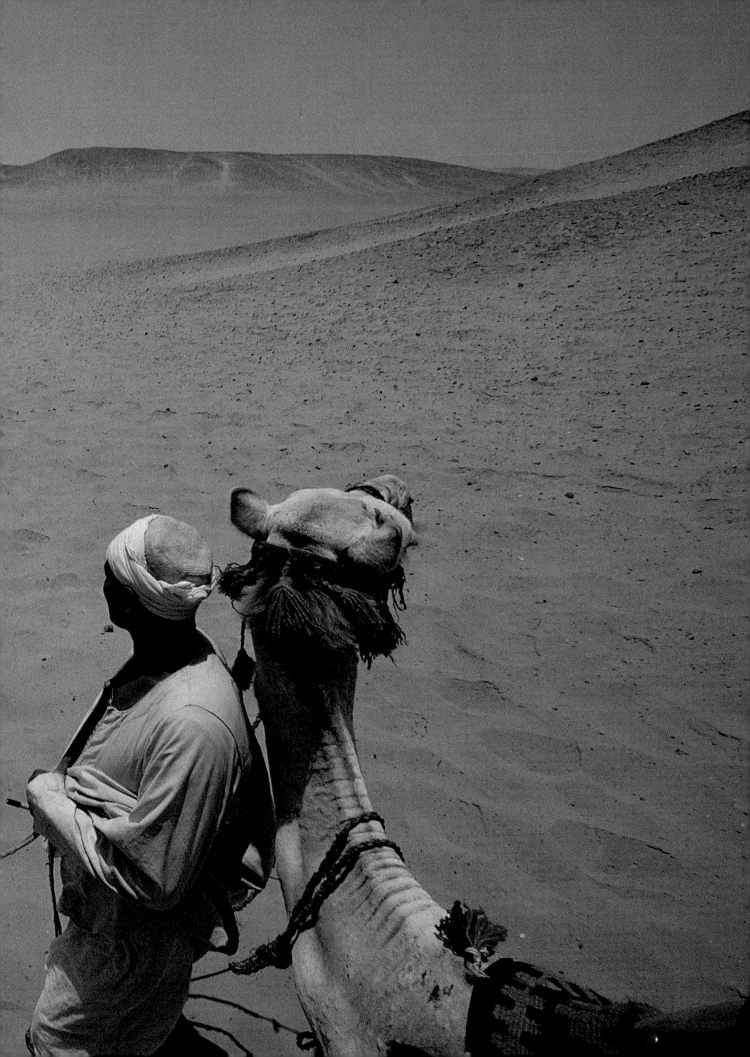

The earthy gold color of the walls, photographed in midafternoon in open shade, gave a uniform brightness value to this scene, a detailed abstract of a uniquely Portuguese street. The color red was used as the key element here. This closeup view, taken with a 28mm lens and Kodachrome 25, is representative of how a photographer can select a small portion of a scene to tell a color story.

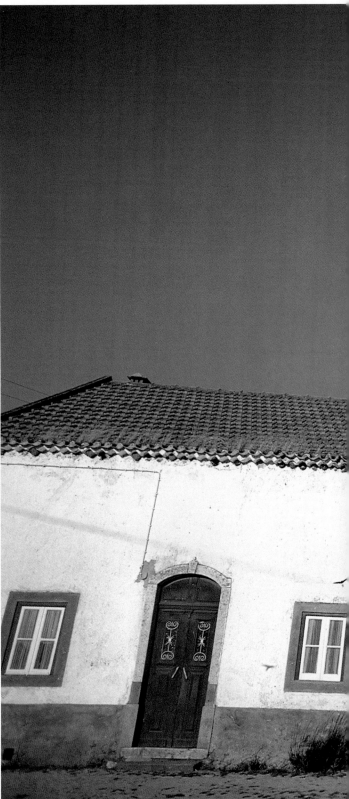

The distinctive architectural design and decorative color of this village building in Portugal seemed to call for a 24mm wide-angle lens and a polarizing screen to record its sweep. Late afternoon light bathed the scene in rich color. I composed the image so that the deep blue of the sky and the hues of the building counterbalanced each other. Then a man and his donkey entered the picture. I find scenes like this one and wait for the right subject to enter the design space.

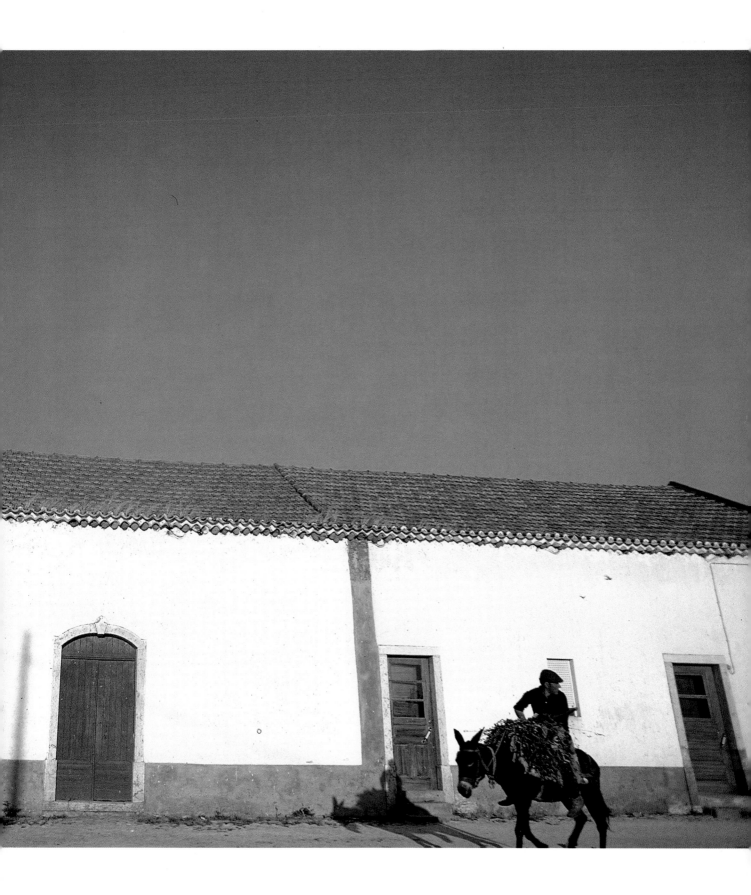

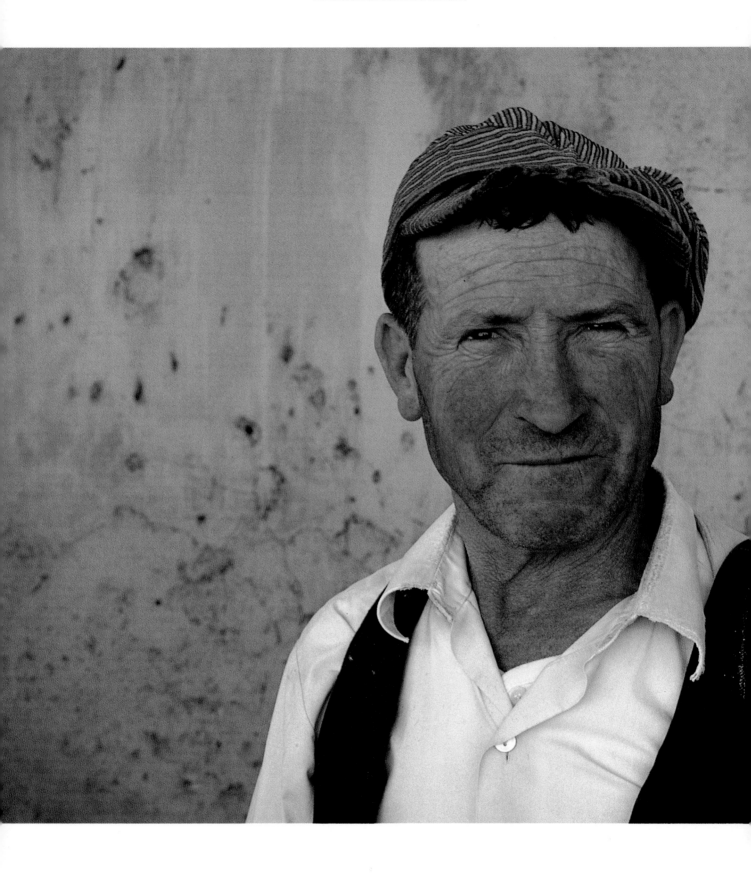

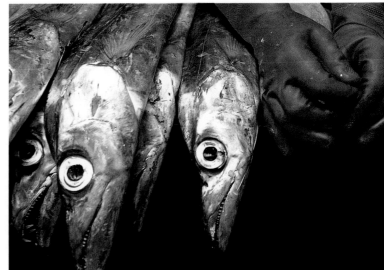

A color environment can be illustrated best by a limited view, a graphic closeup, or a tight shot of one colorful detail that can represent a feeling for a place or an event. In this shot, taken in Lisbon, Portugal, with a 35mm lens, it was barracuda in a fish market. This simple image had just three main components, only one of which (the gloves) was in vivid color.

Shooting in Portugal, I was concentrating on making an abstract photograph of the rich ochre hue of this wall when this man passed by. I asked him to pose for me in the open shade in the late afternoon light, with the wall serving as a backdrop, and was able to capture his rosy complexion. The juxtaposition of the man with the earth-tone background was the main color thrust of this photograph. Here I used Kodachrome 64 and an 85mm lens.

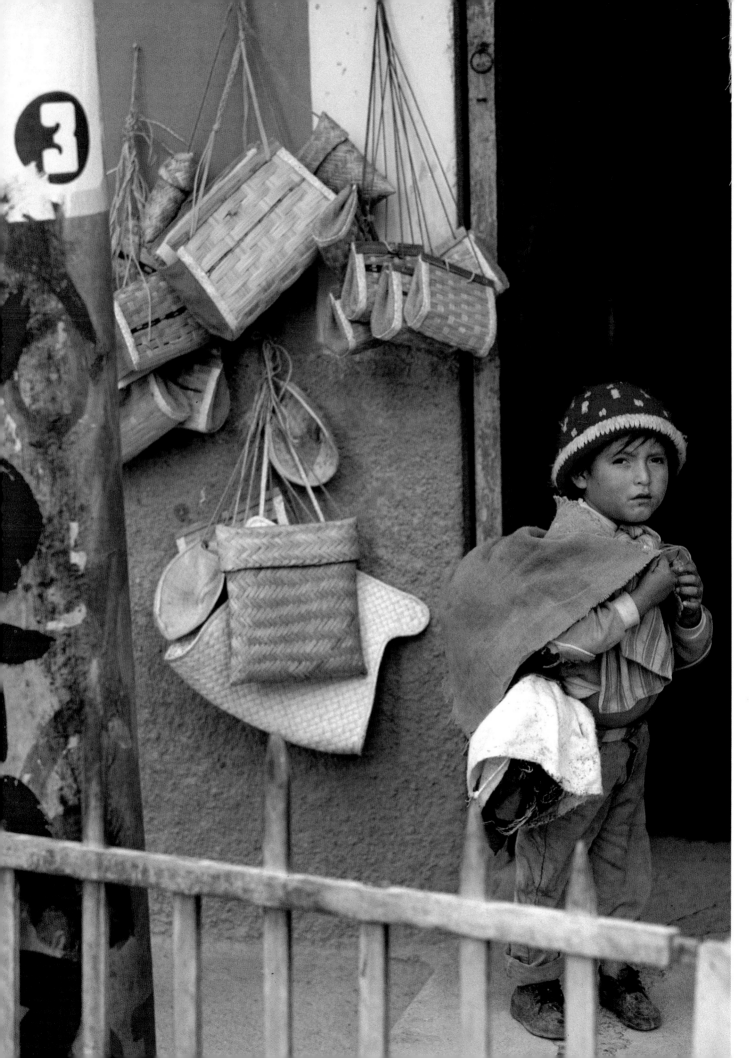

I saw this small girl walk out of a doorway and was able to get several quick exposures of her against the painted corrugated metal storefront. This example of placing a subject in her immediate environment occurred on an early evening walk in Livingstone, Guatemala, a community on the Caribbean coast. The colors reflected the soft, pastel hues of that area. A 24mm wide-angle lens and Fujichrome Professional film, ISO 100, were used. The photographic space was broken up by the various hues and the vertical lines of the storefront.

When photographing people in close situations, whether candid or posed, I find the "portrait" to short telephoto focal lengths, such as the 80mm, 90mm, and 135mm lenses, the best to work with. These lenses usually are fast, can be handheld in low light, and can either present a realistic view or isolate the subject from the background by the use of wide open apertures to limit depth of field, as was done here with a 90mm lens. This small boy turned to pose for me while I was taking some candids of him in Ecuador.

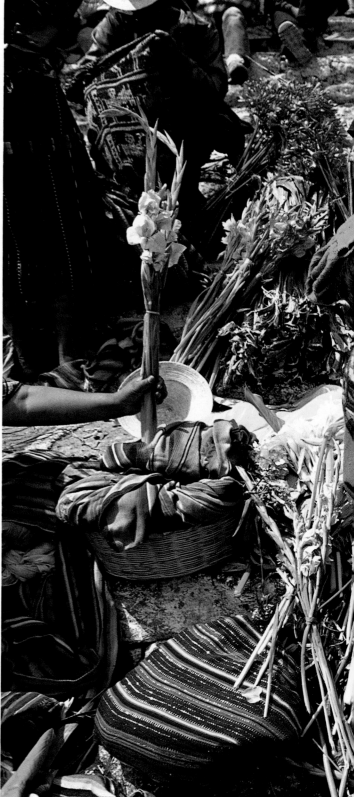

The craftsmanship and colors of everyday products are the living color palette of a culture. These blankets were hanging on display at the "floating garden" markets in Xochimilco, Mexico. I used an 85mm lens at a working distance of about five feet to get this flat view of a random collection of color designs.

"Color in Disarray" could be the title of this incredible assortment of people and colors in the Sunday market in Chichicastenango, New Mexico. I was dazzled by the assault on my visual senses and tried to capture, in this eye-level view, what confronted me that day in the midmorning light. Because of the area that had to be covered by my 35mm lens, I decided to illustrate the interaction of colors on each other and the whole scene in general by placing myself in the direct center of activity and shooting panoramas of the spectacle.

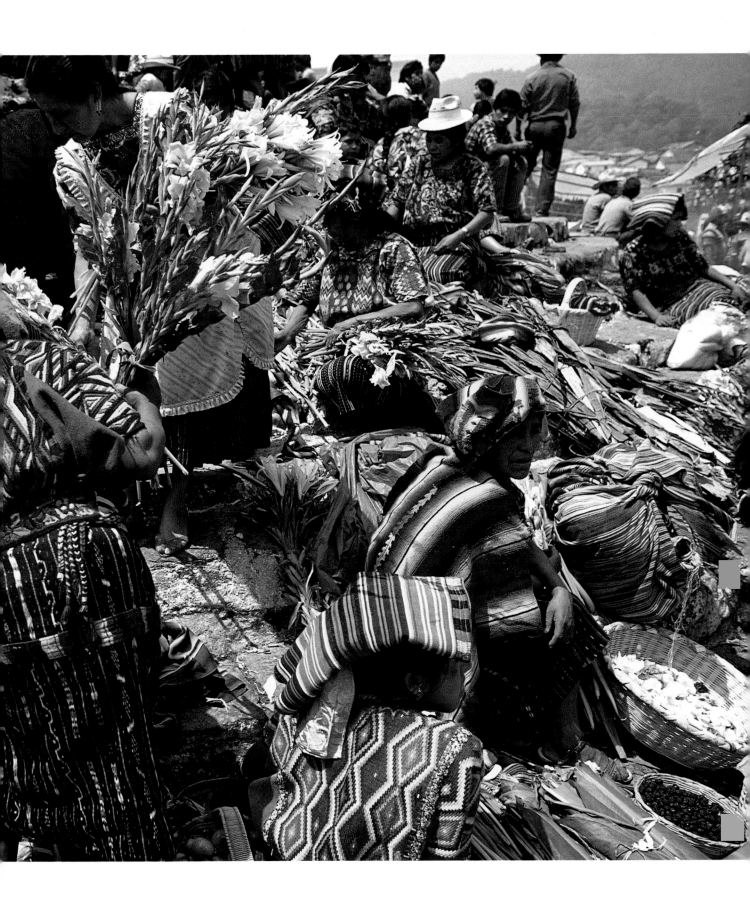

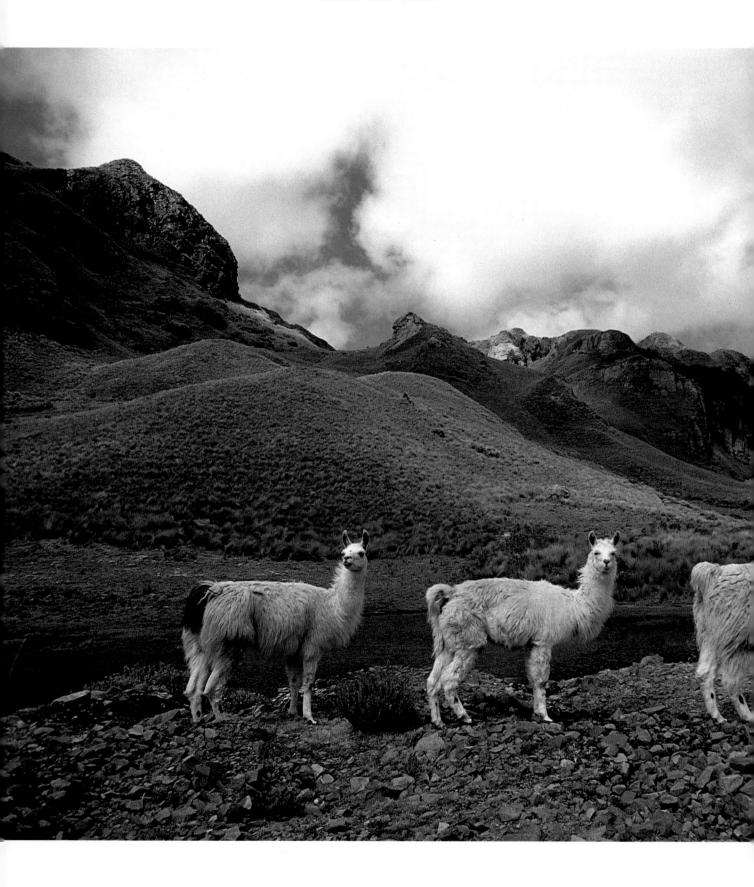

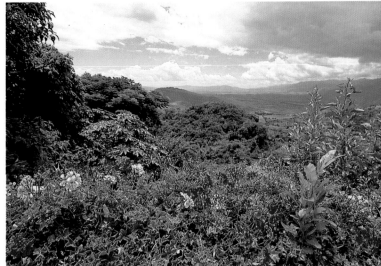

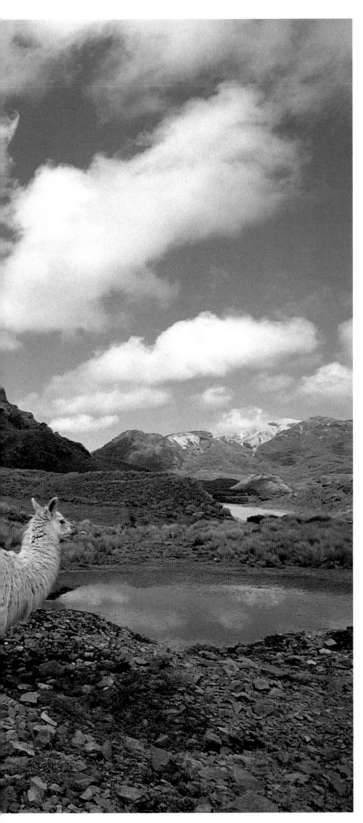

I shot this scene at eye level to give it a natural look and chose to focus on the foreground. I used a 24mm lens, and a midrange f-stop allowed the cool green background to recede visually. The immediacy of the bright-colored flowers gave an instant impression of the luxuriant Oaxaca Valley in Monte Alban, Mexico, on a hot summer afternoon.

In the surreal setting, an Andean mountaintop in Ecuador, I photographed these three llamas with a 90mm lens. The clarity of the mountain light was enhanced by the white clouds and the light colors of the animals. The picture was taken from an eye-level position, and the forms appeared natural. In this photograph, simple composition and good luck play equal parts.

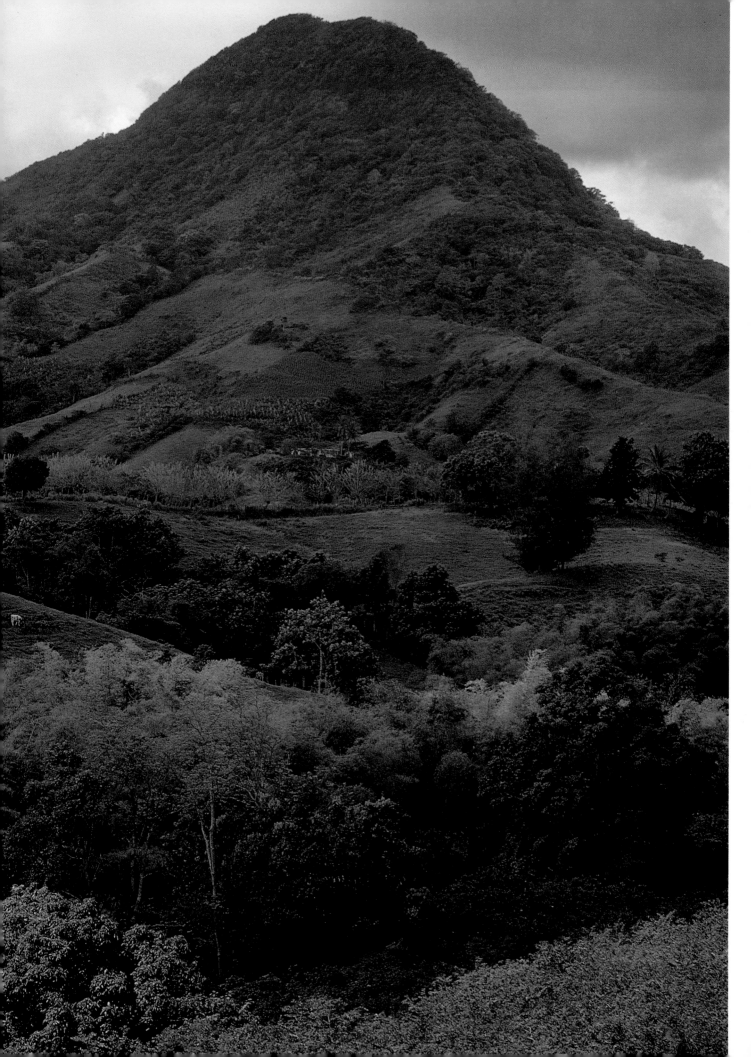

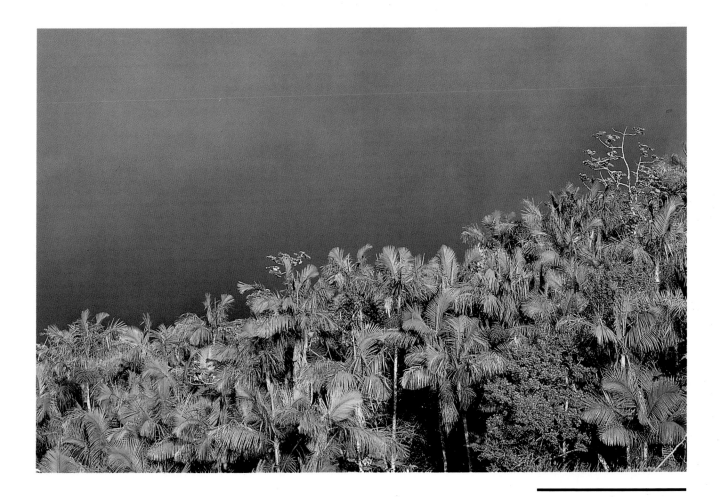

After a late morning shower, warm, directional light gave a sculptured look to the verdant greens of this rain forest in Puerto Rico. Tight cropping set the brightly illuminated greens against a background of deep gray sky, which enhanced the vibrancy of the scene; a 180mm lens added a compressed look to the diagonal composition.

This jungle mountain in Puerto Rico was lush; late-morning sun had passed behind the clouds. I used a 180mm telephoto lens, handheld, and Kodachrome film to capture the serene colors that appeared under this special kind of light—it was as if a giant soft-box studio light illuminated the scene. The humidity and stillness of the landscape were evident in the warm colors of the vegetation and the low-hanging clouds.

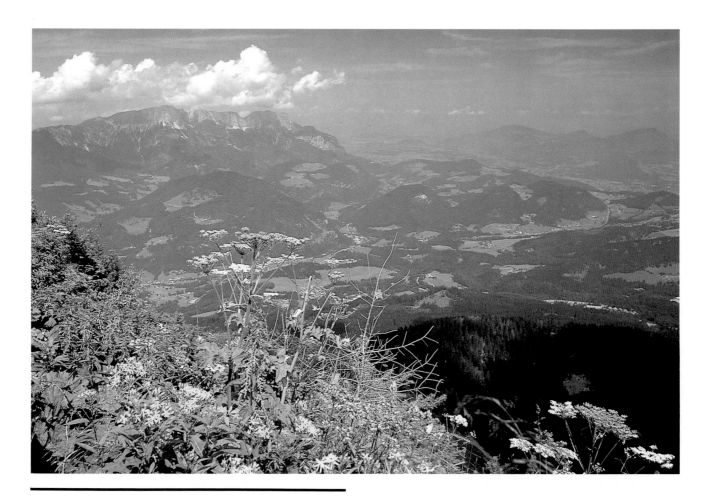

I used a 24mm wide-angle lens set at *f*/11 and a polarizing screen to emphasize the vastness of space and sweeping light in this mountain panorama. A polarizer reduced the aerial haze and improved contrast and the saturation of the colors. The clear foreground light helped to create a three-dimensional feeling of immense space, while the vantage point emphasized visual depth. I photographed this spectacular vista in Berchtesgaden, Obersalzburg, Germany.

The warm tone of this photograph came from the late afternoon light reflecting off this medieval German street. The presence of the gold Porsche seemed quite out of place. The angle of view is a diagonal, which added tension to an otherwise complacent scene of this street, photographed with a 50mm lens.

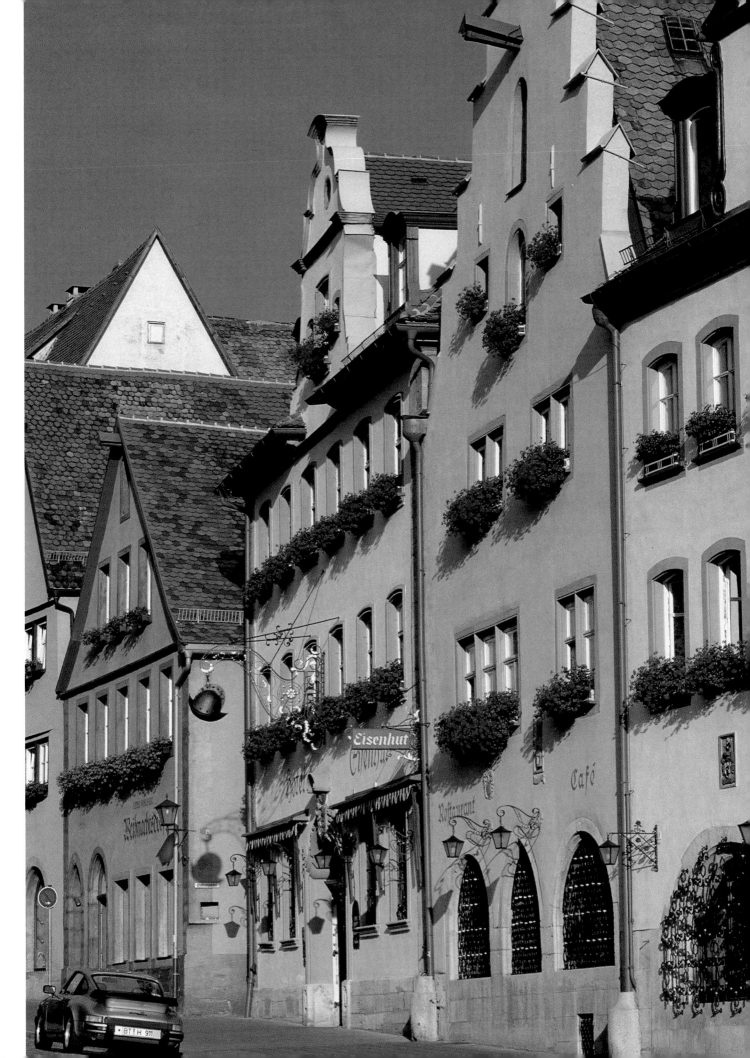

In the city, local color changes at every corner: the cools of shade, the sunlit hot spots, the mixed colors of walls and storefronts, the clothing of the people— all are aspects of environmental photography in the inner city. As in nature photography, local visibility can be from a few feet to infinity; a small alley or an expansive avenue can comprise the visual horizon. I came across this man relaxing on a hot summer morning in colorful Manhattan. I shot at eyelevel to get as natural-looking a perspective as possible.

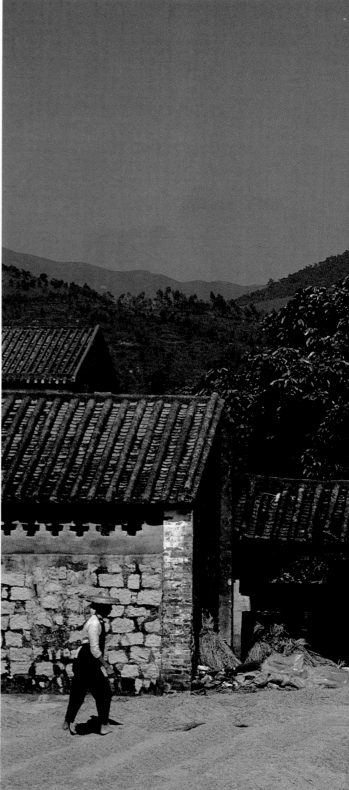

Capturing the harmony between the home and farmers and the landscape was the idea behind this photograph, taken in South China. The rich green shapes of the mountains and the yellows and whites of the house and field combined with the two people, who balanced the composition. The compression effect was created by using the maximum extension of 80–200mm telephoto lens. The action is taking place in the lower third of the frame, leaving the eye free to roam to still-in-focus background. To ensure good depth of field, ƒ/16 was used.

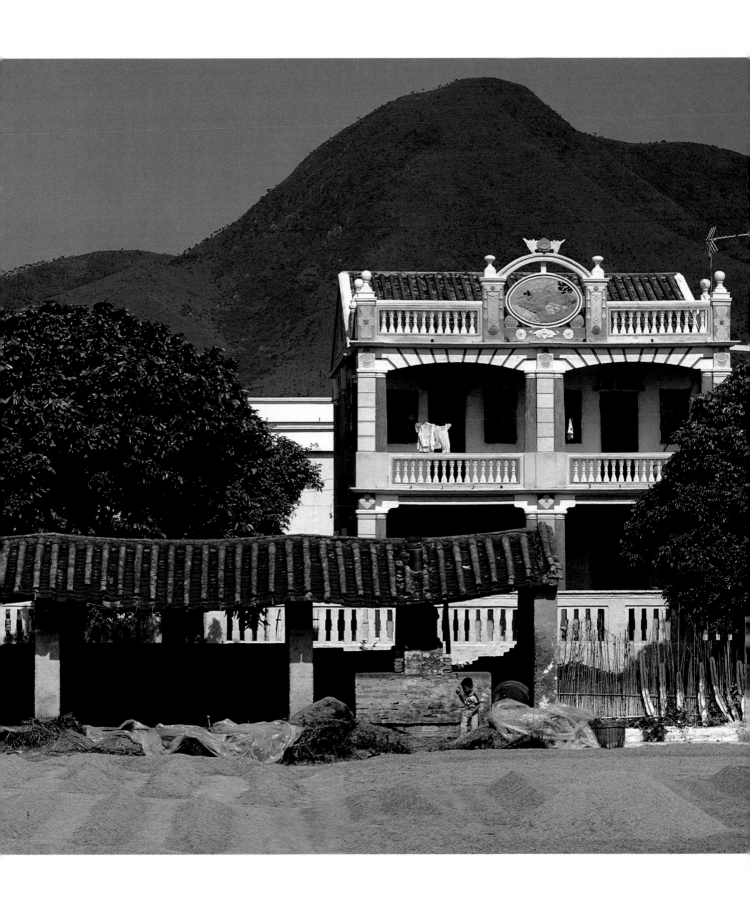

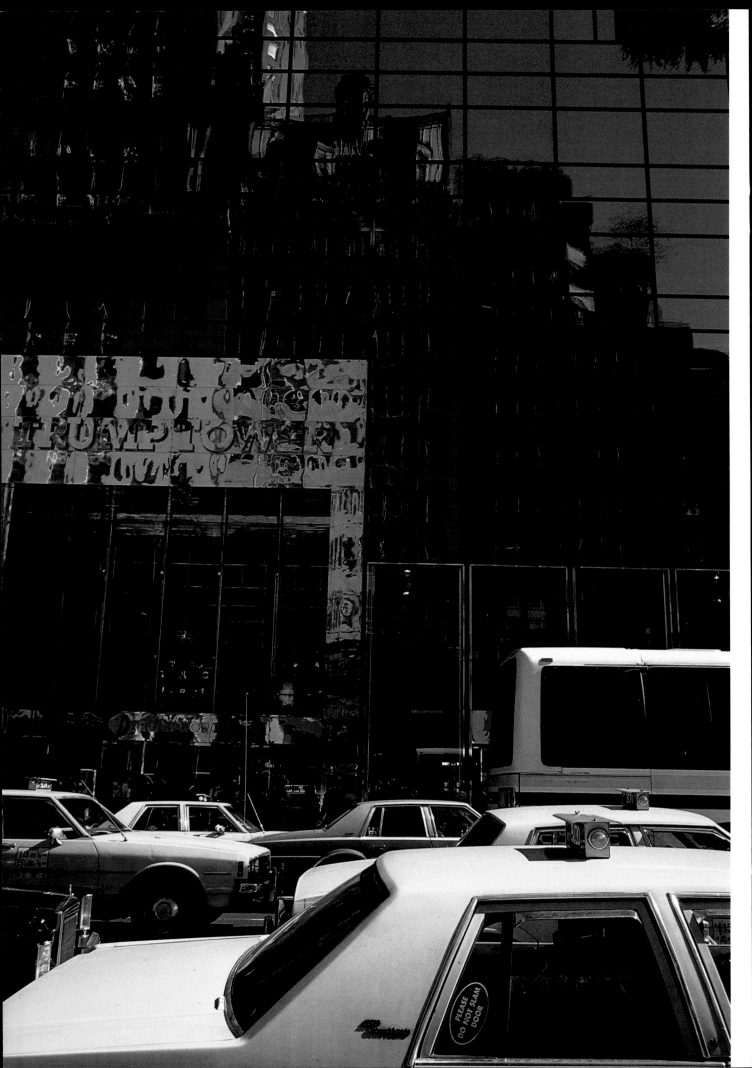

A summer downpour in New York City beat on the slick yellow taxis that reflected the neon light shining above them. The colors of the city at night in the rain open endless possibilities for experimentation with color emulsions, time exposures, and depth-of-field abstraction. The light on the taxicabs and the glossy sheen of the sidewalk created "city color," an odd mixture of lights and darks, brights and dulls, dirty and beautiful color that only night in a metropolis can produce. I shot this photograph on ISO 400 daylight film while leaning out my studio window and handholding a 105mm lens.

The yellows of these taxis contrasted with the sleek darkness of the glass building, which reflected other buildings that surround it. I used a 28mm wide-angle lens to get good depth of field and a sense of foreground-to-background proportion. A dominant color in a photograph can tell a visual story, such as these yellow taxicabs in New York City, or red double-decker buses in London. These familiar images lend themselves to "downtown, city-on-the-go" graphics.

THE NEIGHBORHOODS of North Beach and Chinatown border each other in San Francisco, California. They are ethnic, graphic, hip, easygoing, thriving residential districts filled with little cafés, Chinese and Italian restaurants, chic clothing stores, specialty shops, apartment houses, and lofts. There is an abundance of "local color" to see and photograph. I noticed the use of the colors red and green in every possible tint and shade and decided to try to capture some of their varying personalities in a series of photographs in which the colors appear together. Sometimes the spirit of a place can be best reflected in fragments, symbols, and tight shots rather than panoramic views. Here, the strong color theme unites these pictures of North Beach and Chinatown.

For this shot, taken in North Beach with a 90mm lens, the late afternoon light acted like a spotlight. The red was blaring and the deep green was rich. The checkered white tile design of the wall added to the contrast between and the "punch" of the colors, which are so common in this part of San Francisco.

The dominant yellowish green of this wall is punctuated by the brilliant red awning. The late afternoon sun cast dark shadows. I photographed this scene in San Francisco's Chinatown with a 35mm lens. A "grab" shot, its overall brightness of color contrasted with the dark windows and doors, and reminded me that San Francisco is a city of contrasts.

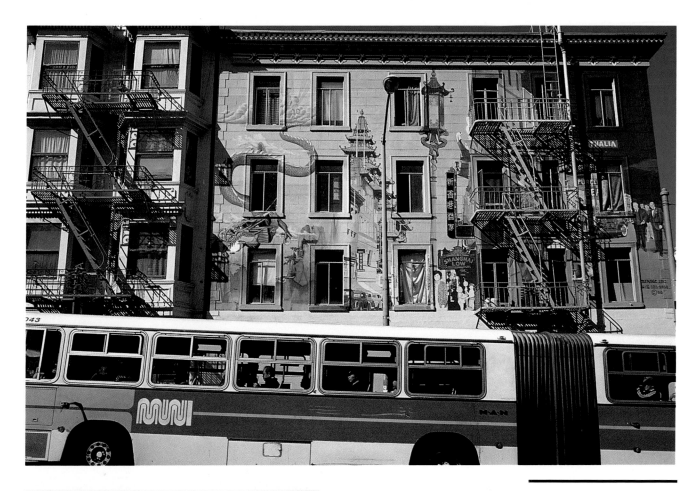

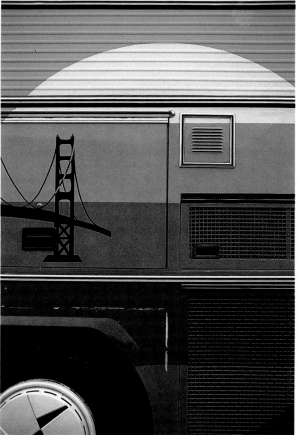

This picture shows a typical scene in San Francisco: a building wall covered with a green and pale blue painting and an orange and red striped bus. The clarity of the afternoon light in Chinatown was undiluted and rendered the vivid colors seen here. I used a 35mm lens set at a fast shutter speed to stop the motion of the bus.

The graphic designer of the logo succeeded in blending these complementary colors on the side of the metal bus. Shooting on an overcast day in North Beach, I tried to translate the strong colors onto color transparency film in order to create a three-dimensional effect. This study in bright, warm colors reflects the vibrant spirit of the community. I used a 35mm lens for this picture.

MAN-MADE COLOR

The ability to handhold a camera at the slowest possible shutter speed in the lowest possible light can produce technically challenging photographs with dramatic, out-of-the-ordinary results. Here, I used a very fast—ISO 1000—film that was balanced for daylight, in conjunction with an orange filter to change the color ambience of this Parisian night scene on the Seine. The artificial color of the filter and the granularity of the fast film at this low light level combined with the luminous evening light to create a romantic mood. I used a 135mm lens wide open at f/2.8 to get this angle of view.

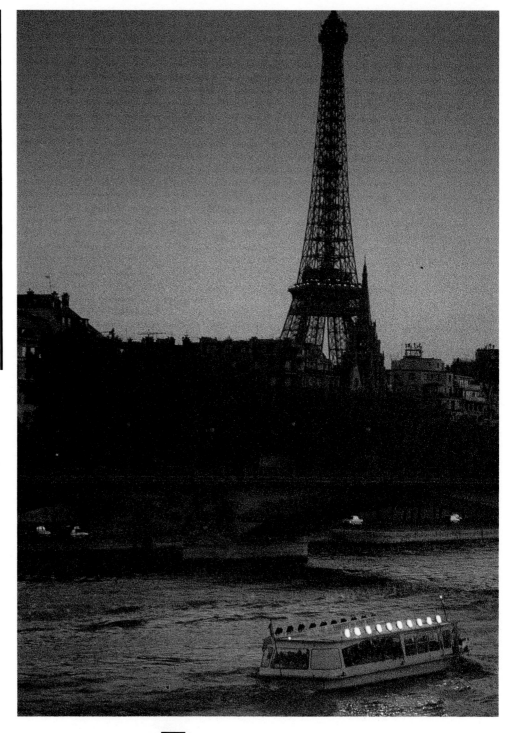

WHEN CONTEMPLATING a subject and its environment, photographers must decide whether the scene is a "natural" and, therefore, should be reproduced as accurately as possible, or whether the scene should be interpreted creatively.

Film is a medium open to experimentation and correction, and compensates for color balance and aesthetics. Photographers can choose film according to the needs of a particular scene. When recording night scenes in which all types of light are mixed, photographers can use tungsten or daylight film, with or without pushing, and get good results. However, with the presence of fluorescent lamps in mixed lighting situations, daylight film produces better results than tungsten film. (When used with a magenta color-compensating filter, though, tungsten film can give fairly accurate color transparencies.)

With electric street signs, tungsten film is usually more appropriate. But some photographers prefer the warm tones that daylight film produces under such conditions.

Filtration is another method through which photographers can record a scene creatively. Light-balancing filters and color-correcting filters are the two types of filters most often associated with color film. The first group of filters modifies a given type of incident light, transforming it into the type of light for which color film is balanced. When making an exposure with such filters, photographers remember the density in translating the filter factor. Deep blue filters can create a fair substitute for natural daylight when used with tungsten film.

The overabundance of bluish ultraviolet light in the atmosphere on overcast days affects the final color of photographs and creates a "cold" impression. Skylight and light amber filters compensate for this color shift and add a more natural, warmer look to photographs. These filters can also be used in open shade to modify the blues. Skylight filters can also be used with telephoto lenses to cut down the amount of haze this type of lens ordinarily amplifies.

Unlike skylight and amber filters, however, there is no slight warming tone to ultraviolet filters. Like the others, though, they require no exposure compensation and protect lenses from the elements.

Color-correction filters give added control over color atmospheres and are used to correct the color shifts caused by artificial lights, including fluorescent, mercury vapor, and sodium vapor lamps. These filters also correct for color casts and reciprocity failure. It is, however, difficult to be precise when correcting the color balance of artificial light, particularly fluorescent lamps. But, by holding the filter to your eye, you can estimate its effect. In general, fluorescent lamps cast greenish light, which can be corrected by using green's complementary color, magenta, to filter daylight film. The deeper the color cast, the darker the filter should be. A blue filter corrects the yellow color of sodium vapor lights, while a red filter does the same for the bluish quality of mercury vapor lights.

Neutral density filters cut down the overall amount of light reaching the film, which provides photographers with more control over the aperture and shutter speed. This is important when shooting under bright conditions, such as at the beach, in the desert, or on a snowy field. These filters can also be used in conjunction with other color filters without interfering with the color characteristic of the other filter; the exposure time is simply reduced. Such stacking of filters, however, is not recommended with wide-angle lenses.

Practice is necessary for the spontaneity required to use filters successfully in the field, to reveal your creative color interpretations of striking scenes.

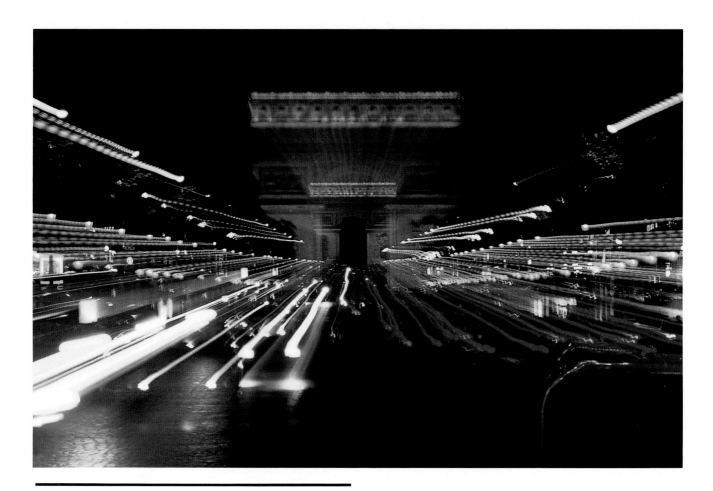

"Time vision" was evident in the light streaks created by the hectic traffic surrounding the Arc de Triomphe in Paris during a long (1 sec.) time exposure at night. The basic effect was exaggerated by zooming the lens while the shutter was open. Any time the shutter is opened for a long period of time, some phenomena becomes visible—such as these light tracks—that is impossible to see with the naked eye. This is a photographic realm where artistic creativity and the "unknown" world combine to produce pictures that can be accepted as reality—or as surreality.

For this nightscape of a rainy street in Washington, DC, I photographed with a 35mm *f*/4 lens handheld for 1/15 sec. The purpose was to try to add an air of political intrigue: the wet street, the dome of the Capitol, the red-light blur of the car, and the tilted angle of the shot all combined to make this a scene appropriate for a spy novel. The color balance of the film—indoor film pushed to ISO 400 for greater sensitivity—was correct for the tungsten lighting on the building and the street lamps.

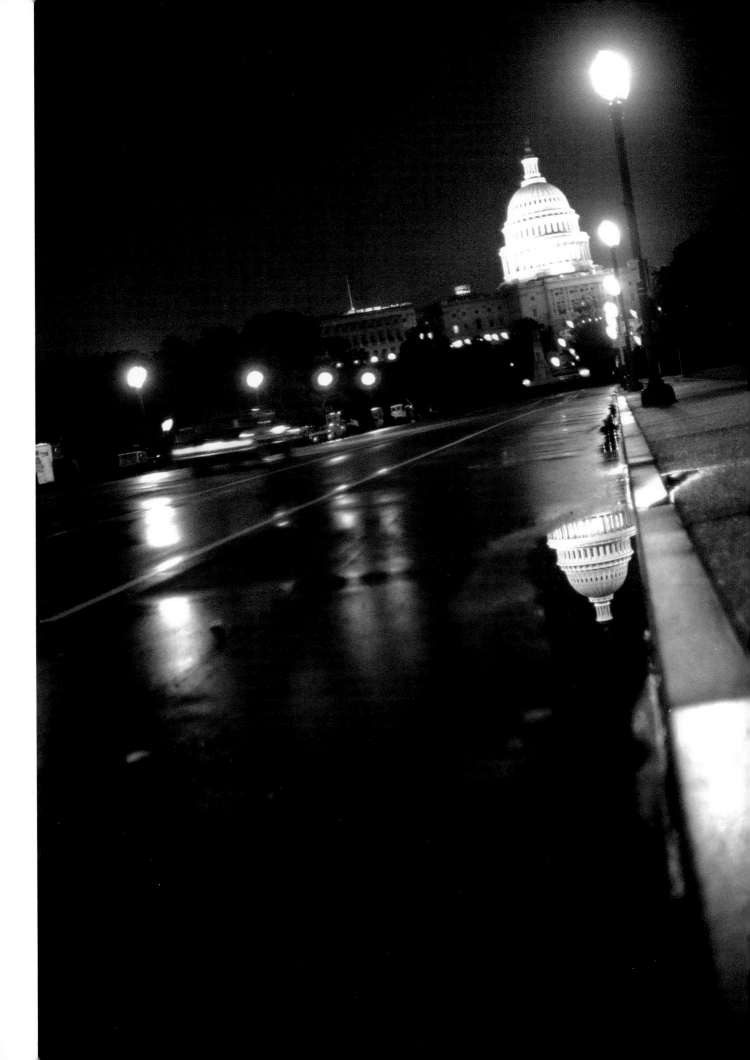

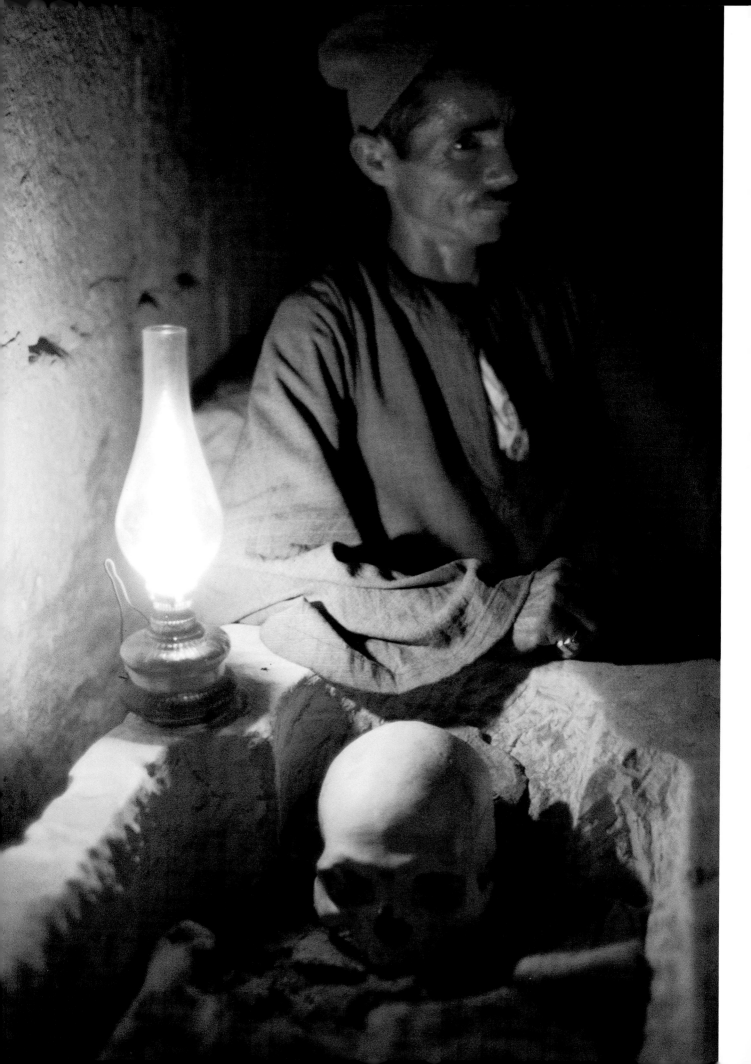

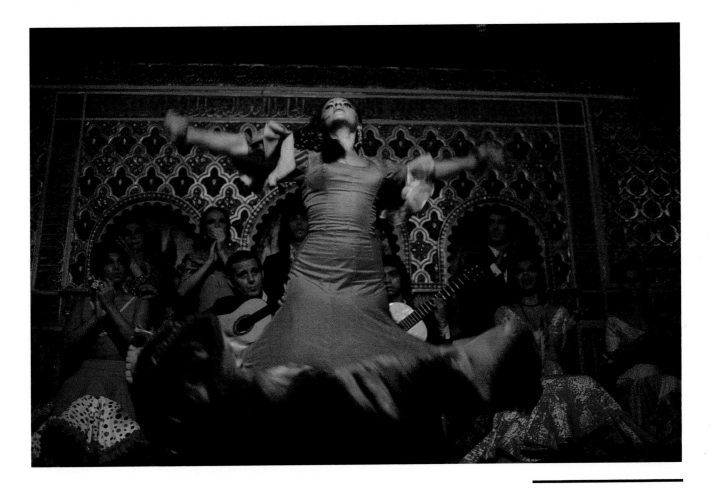

The flamenco dancer in this small Spanish cabaret was caught in midmotion by a high-speed daylight film (ISO 400) and a 35mm lens at 1/15 sec. The bright tones captured the excitement of the dimly lit interior. The focus on the dancer's face, which appeared sharply detailed while the hands were blurred, conveyed a feeling of the dance. A correctly balanced (tungsten) film would have been technically more accurate but not as aesthetically effective.

This image was a pure example of manipulating color temperature and mood by using a film that was incorrectly balanced to record the correct color temperature of a given situation. Here, the use of daylight film under indoor conditions produced warm orange and earth tones to render the Egyptian tomb in the color palette of an Old-Master painting. I braced myself against the mummy's sarcophagus and handheld the 35mm f/1.4 lens wide open for 1/4 sec. to expose the ISO 400 film. Either a gas lamp or an incandescent bulb will influence the color-cast of a picture when the level of light is low.

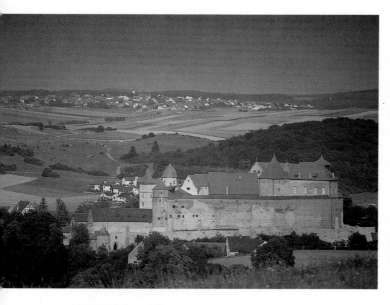

A 180mm lens used with an orange filter added a fairy-tale look to this picture of a castle in Franconia, West Germany. Obviously, the colors were tinted considerably for effect. It is, however, the beholder's option to believe what is realistic and natural in a landscape photograph or what is designed specifically to create a new imaginative reality.

This sepia-toned image of a mosque and waterfront in Istanbul, Turkey, was taken from a ferry on the Bosporus. Because the day was overcast, I used a warming filter in order to take advantage of the light gray sky. This completely changed the color atmosphere of the scene, from cool to warm hues. The whites of the steamers prevail, despite the photograph's artificial color cast. Shooting from a distance, I used a 135mm lens.

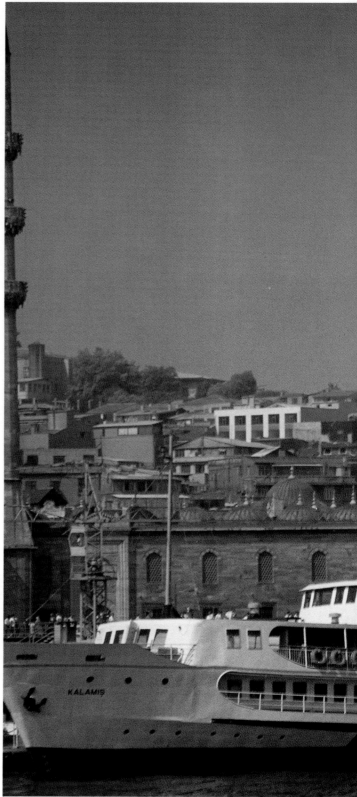

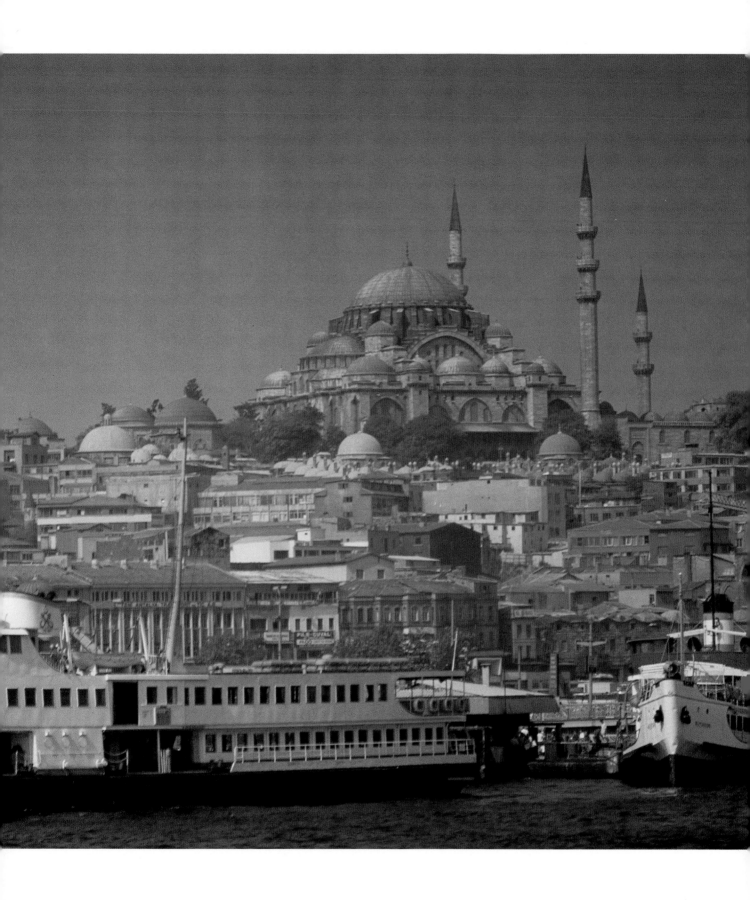

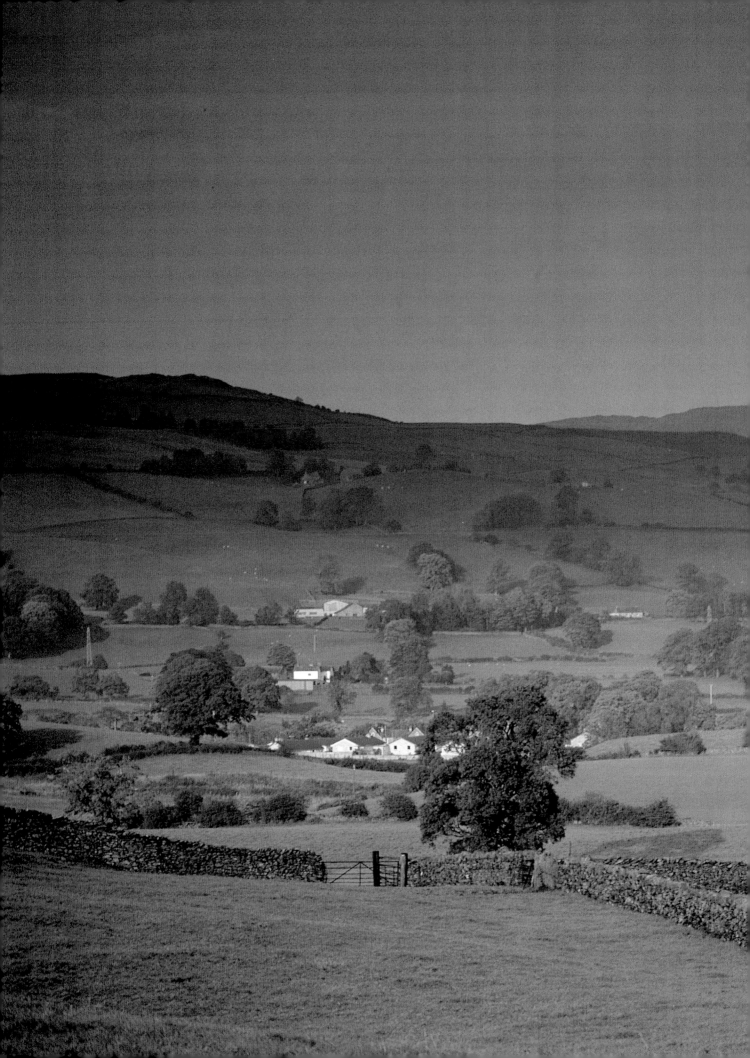

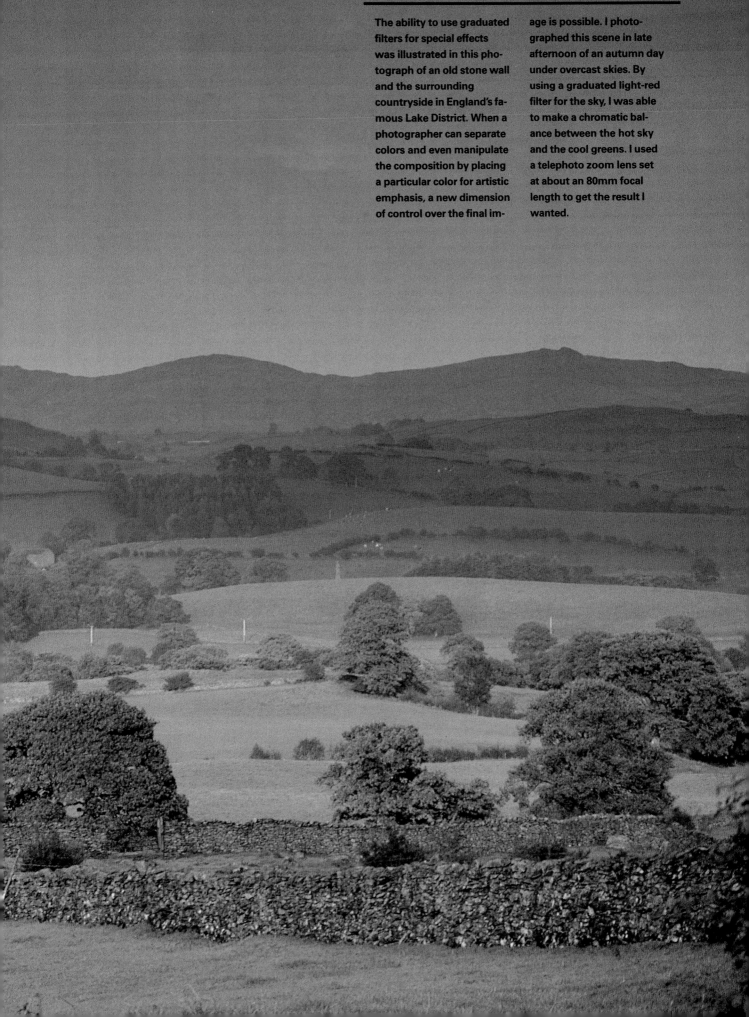

The ability to use graduated filters for special effects was illustrated in this photograph of an old stone wall and the surrounding countryside in England's famous Lake District. When a photographer can separate colors and even manipulate the composition by placing a particular color for artistic emphasis, a new dimension of control over the final image is possible. I photographed this scene in late afternoon of an autumn day under overcast skies. By using a graduated light-red filter for the sky, I was able to make a chromatic balance between the hot sky and the cool greens. I used a telephoto zoom lens set at about an 80mm focal length to get the result I wanted.

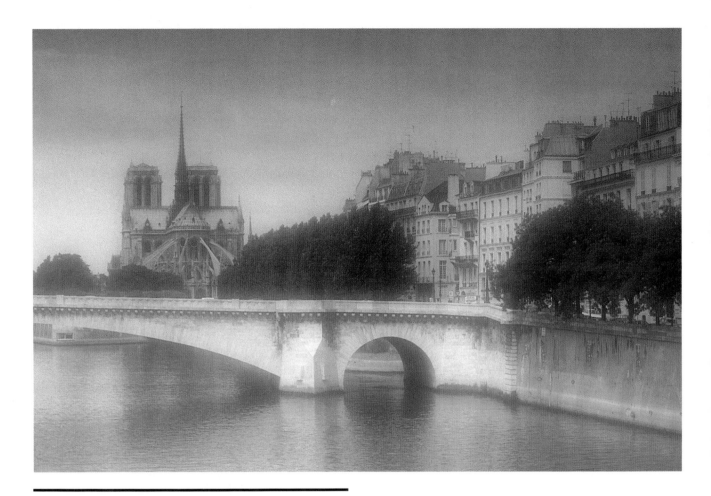

Seeing this scene as a purely impressionistic vision of color detail was the basis for this stylized photograph of Notre Dame cathedral in Paris. In order to put my feelings on film, I used a combination of a diffusion screen and a light amber filter and flattened the scene slightly by using a 135mm lens. The execution of this quiet study was made possible only by the use of filters to alter the basic color and resolution qualities of the final photograph.

An atmosphere of softness was added to this triangular composition through the use of a diffusion filter. The picture area is broken into four shapes with color triangles and lines. The black shape of the foreground boat balances the bright, advancing red in the background of this shot taken in London with a 35mm lens.

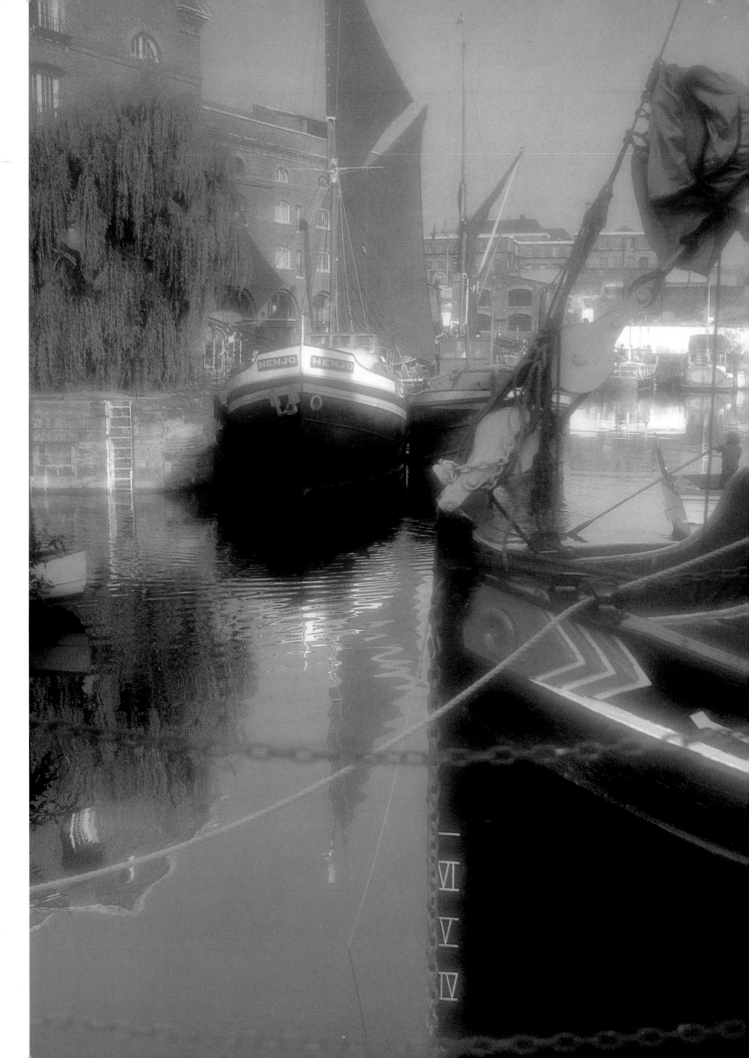

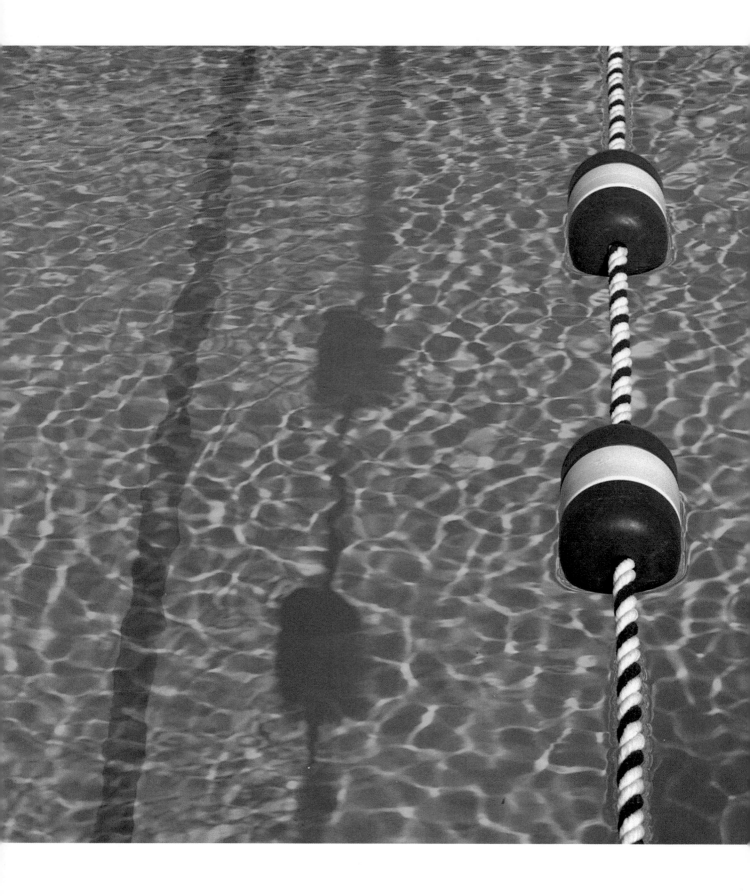

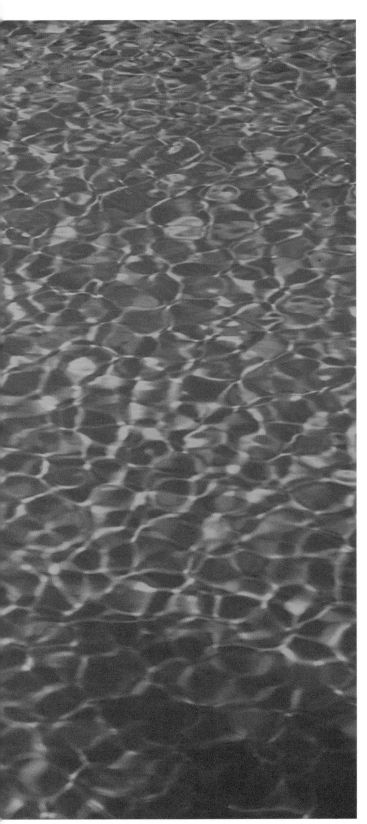

For this photograph of bright yellow leaves, which I came upon quite by surprise in New Jersey, I deliberately overexposed by one stop to ensure an airy lightness in the quality of the overall color. In this case again, the aesthetic exposure was the creative choice, the right one for the concept being portrayed: a well-detailed and accurately exposed photograph of this subject would not have been as exciting. I used an 80mm lens, and a fast shutter speed to freeze the slight movement of the leaves in the breeze.

Artificial paint, like the aqua blue of the bottom of this pool, can come alive under the right lighting. Here, the Florida sun produced a high intensity that, with the water in the pool, deepened the color. The ripples on the pool's surface and the shadow of the guard rope on its floor were used as design elements. A 35mm ƒ/2 lens and slight overexposure captured the specular highlights on the ripples accurately.

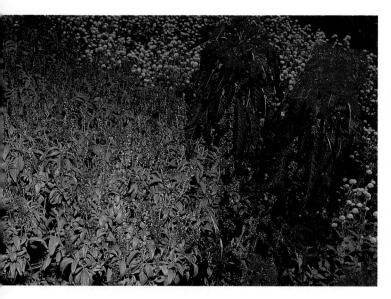

These bizarre-looking flowers were photographed with a portable electronic flash unit on an overcast day in Bermuda with a 60mm macro lens. The power of the lamp to add brilliance, to expand the color personality of the scene, to saturate the colors, and to define and separate details makes it a useful alternative to available light. In actuality, if you have a flash unit with you, you have "available" light.

A modern flash unit can add the extra punch for graphic color, as well as for fill-in lighting or snapshot photography. These two red leaves were photographed at night in New Jersey with a 60mm macro lens and a powerful portable flash unit. The only illumination was the bright flash. This can be seen reflecting in the wet surface of the leaves. In essence, a flash can be thought of as man-made color because it offers an alternative to natural illumination.

WHEN A PHOTOGRAPHER works with infrared color film, what results can only be described as unpredictable color, invisible to the human eye, but recordable as startling color displays on a special film. Infrared film is sensitized to green, red, and infrared wavelengths and records as a positive yellow image in the green layer, magenta in the red layer, and cyan in the infrared layer. Infrared film is also quite sensitive to heat, and that characteristic alone can change the recorded image drastically from hour to hour. Also, long exposures change color greatly, as do mixed-light situations. In truth, there are no absolutes about the color responses of this type of film. Because the exposure latitude of infrared film is limited and erratic, bracketing several exposures of each frame in both directions is essential.

The visible spectrum forms the colors that our eyes see as "normal." When using infrared film, a photographer leaves the visible spectrum and enters the realm of unpredictable color, the world of radiant energy. The infrared radiation, which is made up of wavelengths longer than those of visible red light, can be recorded by a special film. I photographed this blue scene of the Nile riverboat in Egypt through a 15mm lens on a very humid day, using infrared-sensitive film and a red filter to produce this startling result—which was impossible to see when I composed the picture. Heat intensity and switching to different filters can alter the way infrared film records the invisible spectrum.

In the heat of the Florida Everglades, I photographed this mangrove swamp through a blue filter with a 24mm lens. Unpredictable color and surreal images were made possible by the invisible elements of color vision: sky, foliage, water— all changed color as the temperature changed during the course of the day.

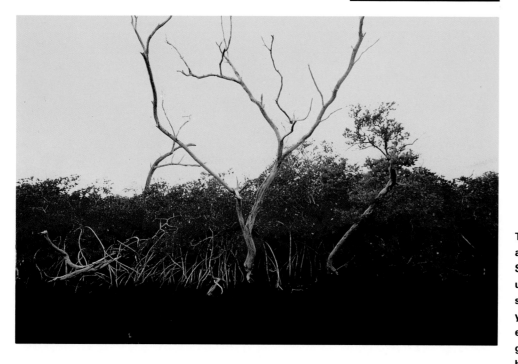

To conjure up a surreal image of a valley in Southern Spain, I used a 15mm lens up close to the fence, a small aperture (f/16), and a yellow filter to get this effect of an overwhelming green sky, red grass, and black graphic fence on infrared-sensitive color film. The floating elements of the very-wide-angle lens made it possible for me to focus this close and still maintain an exaggerated but realistic perspective.

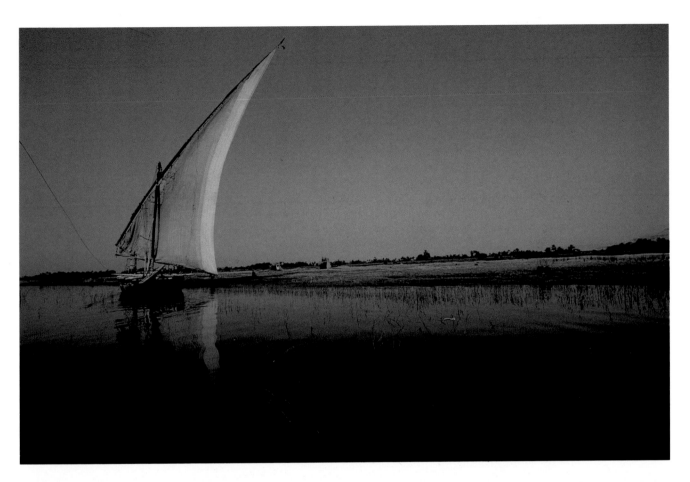

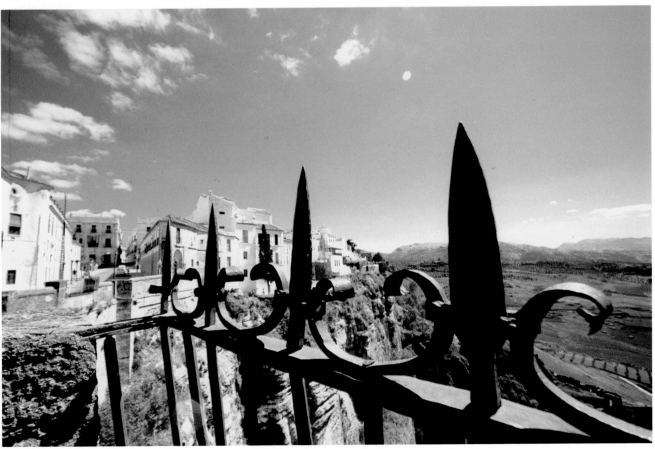

24-HOUR COLOR

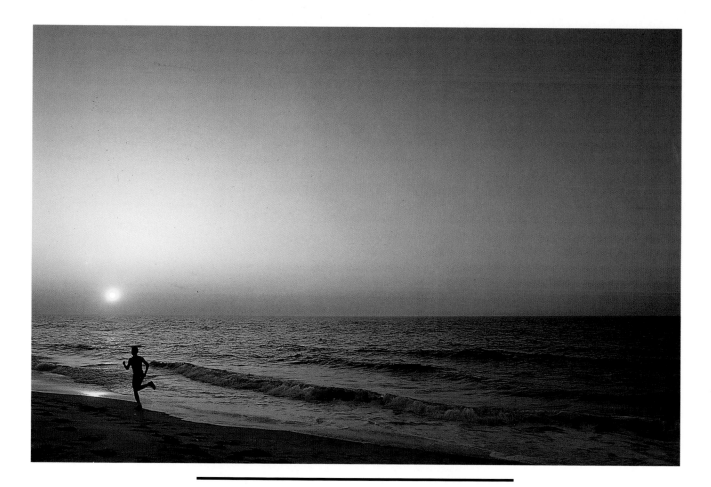

This summer sunrise over Long Island, New York, was photographed with a 35mm lens wide open at ƒ/1.4. I waited for the runner to reach the brightest part of the picture before releasing the shutter. What Homer called the "rosy-fingered dawn" cast its first light upon the living scene, and shadows and highlights were for the first time obvious.

THE QUALITY OF light—the language of the camera—changes with the passage of time throughout the phases of the day and night—and so does the way the world looks. With each day, colors are born, develop, mature, and fade. More than anyone else, the creative photographer must be aware of the changes in the quality of the light at hand to use it well.

From the first light of dawn creeping over the horizon, to the relentless overhead light of the noonday sun, and, finally to the dying light of sunset, light is, more or less, bent as it travels through the atmosphere. This determines the color of the light we see.

Before dawn, flat monotones of color are visible. They represent the infancy of the day's light, weak and gentle; the atmosphere is still and quiet, and the mood is cool. There is little contrast and shallow depth of field. Shadowless objects seem one-dimensional.

Quickly, colors are born with the first touches of light. The rising sun casts a directional light. New, vibrant, warm colors begin to replace the dark shadows and deep blues, and the visual details of the day are evident. Exposures must be adjusted almost continually during this period, until the warmth of morning's sidelight glows amber-yellow, textures come to life in full color, and shade appears.

Colors are perceived at their truest when the sun is directly overhead at its highest elevation and fullest intensity, reaching the earth as white light. This produces details and outlines with absolute clarity. Often stark and harsh, the noon sun, especially during the summer, does not produce the most interesting photographs. The sun seems to act like a giant spotlight. But dramatic effects can result from your use of strong shapes and unusual angles that benefit from dimensionless light.

Taken at midday, panoramic shots confuse the eye, since contrast and shadows form black gaps in landscape images. The use of color as a main theme for closeups and detailed images can, however, bring rewarding results at midday: weaker colors are washed out, and strong shadows are created. Beautiful shades of reflected light are also produced when intense light bounces off such planes as snow, beaches, and rooftops. This is the reflectance that color film is balanced for. Remember to keep your back to the sun during these hours.

The colors of late afternoon are rich, with an interplay of shadows and highlights, and they add a new dimension to color and the day. This is when sidelighting is at its grandest, with colors basking in orange light that is very different from morning's light amber. Long shadows and saturated hues mix, and deep divisions in the landscape appear. It is no wonder that this is called "painter's light." Volume and depth are the key to the landscape now. With the radiant warmth of the sun at its most penetrating angle, patterns take shape: the scenes of midday become three-dimensional, sculpted by sidelighting. There are glints of this light shooting through openings in streets, through trees, and around hills; shadows are active elements, and now, too, exposure changes rapidly. Working with faster film or a tripod is useful, and backlit shots are more possible. Angle is all-important, everything seems photogenic—and the light slips away all too quickly.

The first colors of the night are cool and refreshing. Time exposures of several seconds are required in order to capture a color rendition that is more affected by the film's capacities than by the wavelengths of light. In other words, the film is likely to capture color and light that never actually existed.

Keeping in mind all of this information on the quality of light as it changes throughout the day and night will enable you to create strong images both technically and aesthetically, and manifest your own color vision.

The humid mists of pre-dawn created an eerie feeling over this temple in a jungle clearing in Tikal, Guatemala. I underexposed the image a bit to saturate the colors slightly and to bring out the faint shape of the jungle moon. I used a 135mm lens handheld at *f*/2.8 at 1/15 sec. to shoot this cool monotone.

The Temple of the Jaguar was shrouded in mist at first light deep in the rain forest in Guatemala. Clear white light was overexposed to take advantage of the overall brightness of the scene, as well as the intense amount of reflected white light. I used a 35mm lens and a professional lens shade for the final result.

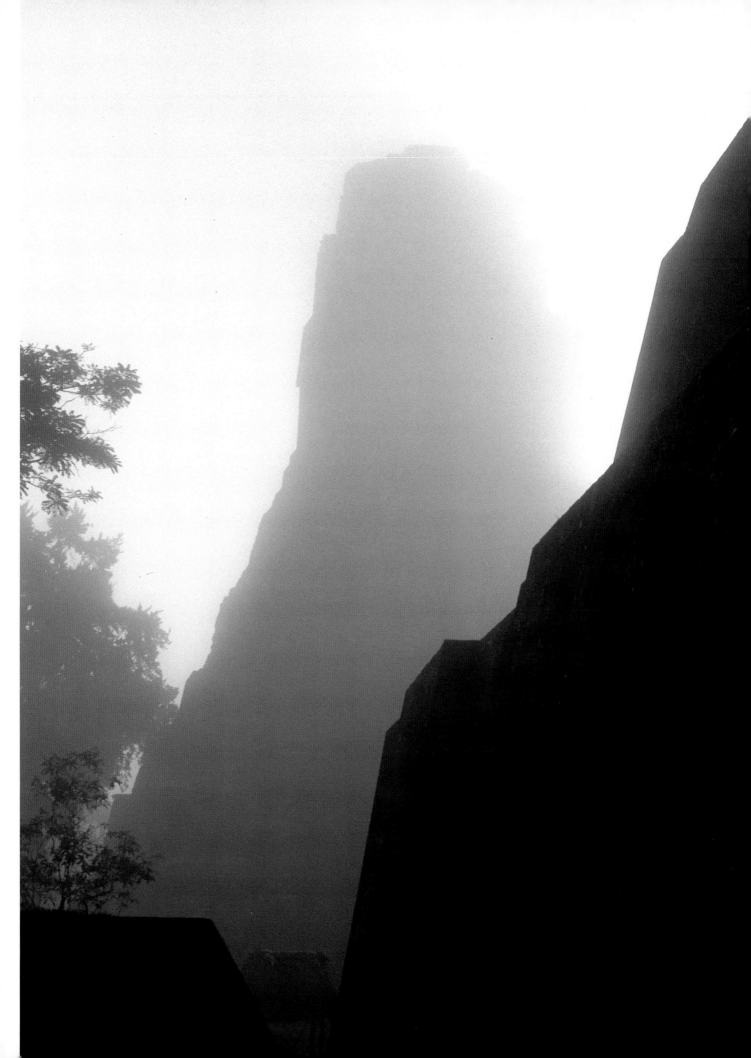

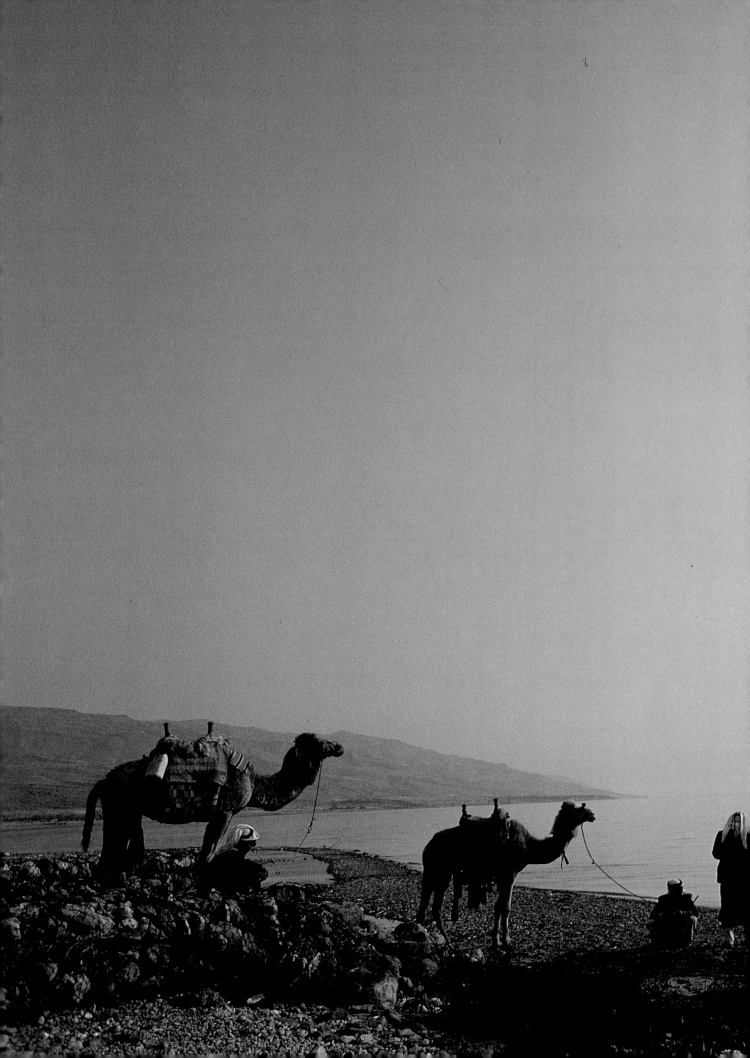

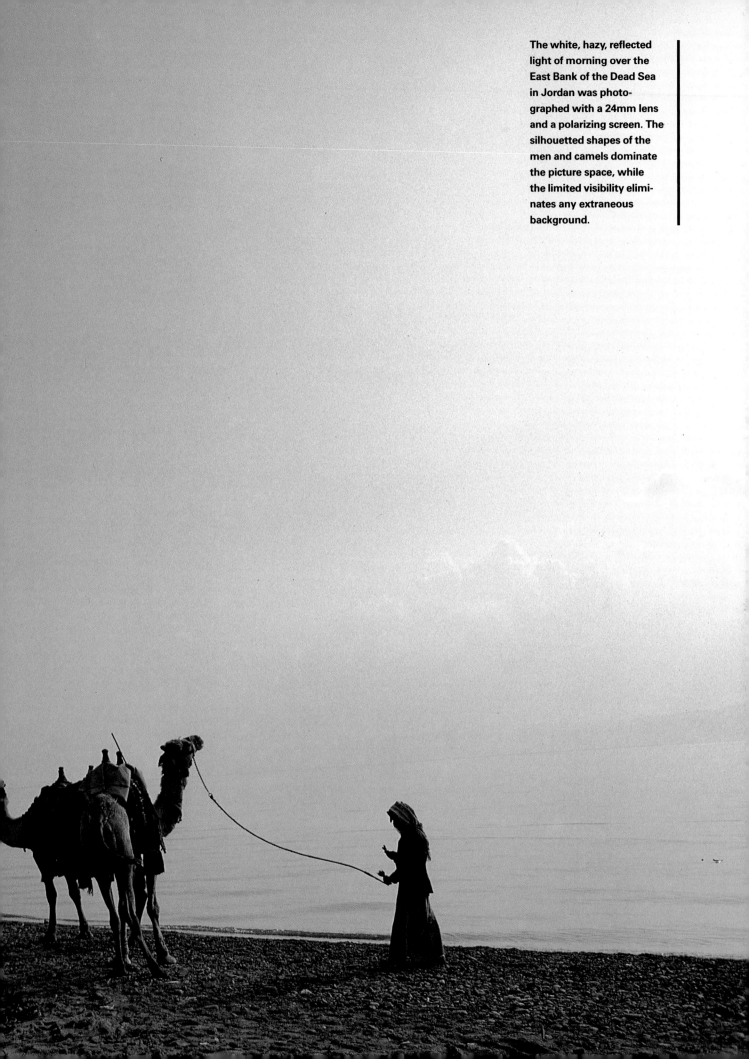

The white, hazy, reflected light of morning over the East Bank of the Dead Sea in Jordan was photographed with a 24mm lens and a polarizing screen. The silhouetted shapes of the men and camels dominate the picture space, while the limited visibility eliminates any extraneous background.

The bright, directional light of the morning sun drenched this 1950s Chevy with a high, glossy light on a small-town street in Pennsylvania one fall morning. The long shadows and the crispness of the amber-yellow sidelight enriched textures and details, providing dimension and color clarity for the first time of the day. A 35mm lens and a professional lens shade were used to retain well-defined image detail despite the strong backlighting of this all-American scene.

The high angle of the diffused white light streaming in through the window in this antique room in Holland helped to sculpture the textures and colors of the objects in the room with a beautiful, even balance. The warm colors of the interior were rich in gradations of tonality and details, even in the shadows. The quality and direction of bright daylight outside a window determine the mood it will cast inside the window, in the room it illuminates. Here, a 35mm _f_/1.4 lens gave me speed and also high resolving power to take advantage of the moody lighting.

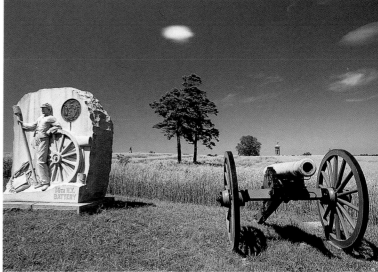

The midday sun cast its brilliance on a cannon and monuments at the Gettysburg battlefield in Pennsylvania. The intensity of the light at noon allowed for good color detail and outline rendering, with well-defined but short shadows, as well as great depth of field. I used a 24mm lens at eye level to keep natural-looking proportions while maintaining a wide-angle perspective.

The well-defined color balance of midday light is excellent for rendering high-intensity contrast. In this image, taken in Portugal, brilliant, saturated yellow on the wall, the rich complementary blue of the sky, and the depth and detail of the green leaves were all characteristic of the "graphic" qualities of light when the sun is directly overhead. I used a 28mm lens to shoot this picture.

The harshness of the midday sun in New York City acted like a giant spotlight to bring out the incredible detail and intense color saturation of this red metal door. I used a 90mm lens and took a light reading directly off the door. Closeups of inanimate objects can be rewarding when made in early afternoon because the strong colors and heavy shadows and outlines that are seen under this light add a stark realism to subjects.

Here in all its brilliance is the noonday sun, shot in Bermuda on Fujichrome 50 with a 50mm lens. The rich, red paint of the wooden door, which is a reflected-light color, has close to the same brightness range as the blue sky, which is, of course, a direct-light color. The slightly overexposed white of the building makes the red that it surrounds look even more intense. This exemplifies the qualities of nearly pure white light, a mixture of red, blue, and green.

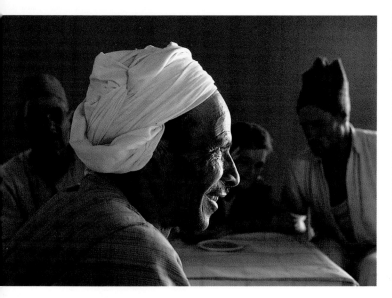

I was able to photograph these Egyptian men in a large red tent in the desert. The hot overhead sun shone strongly through the translucent material, throwing an evenly diffused warm color-cast across the interior. A doorway was open to the sun; this let in a beam of unfiltered white light that highlighted the nearest man's face. Some depth of focus was achieved by using an 85mm lens at its medium aperture.

The veranda of a small café in Crete, Greece. was where I took this quiet portrait of an elderly man in early-evening light. I wanted the blue of the wall and the blue of his eyes to be apparent in the final photograph, so I slightly overexposed it. A 105mm telephoto lens was used at a close working distance; the focus was on his eyes.

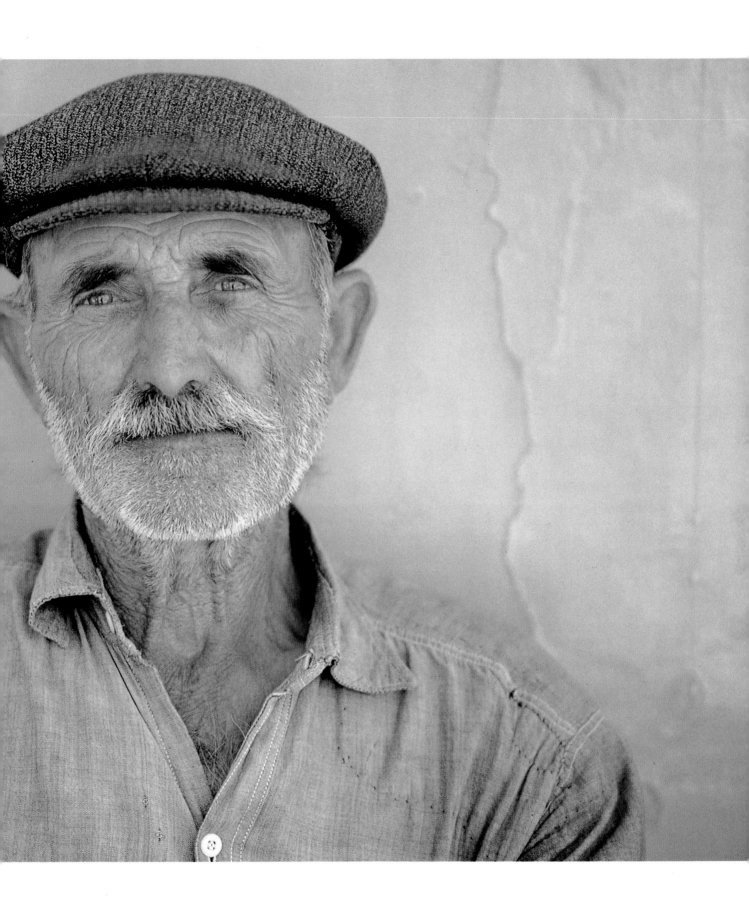

Late afternoon sun in a side street added strong highlights to the twin white bulldogs that sat guard in this window in Oaxaca, Mexico. Another dog had caught their eye, and so they paid me no attention when I photographed them against this graphically outlined wall. I was able to get several quick exposures while they were barking, using an 85mm lens and Kodachrome 64.

Early evening light mixed with the eerie glow of a street lamp to illuminate painted walls. The predominant green tonality caught my eye as I photographed Oaxaca, Mexico, and I tried to reproduce it faithfully in an interesting but simple design. An 85mm lens was used to achieve the close-to-normal-looking perspective in a slightly surreal setting.

I used a 15mm very-wide-angle lens to get this incredible ratio between the Arch of Constantine and the Colosseum in Rome: the bright afternoon light, which made it possible to use a small lens opening, helped to make possible the rendering of detail across the whole plane of focus. The lens was tilted upward deliberately, so as to get a dynamic sweep of line, shape, and form into the picture. The Mediterranean light is known for its warmth and richness in illuminating buildings and landscapes with an almost glowing quality.

Beginning in late afternoon, there is suddenly a slight "warming" of colors. This means that an orange-to-reddish tint is picked up, not only by the human eye but by film as well. Structures are well defined in this light, and textures are enhanced. This photograph of the pyramid and the temple in Uxmal, Mexico, was taken with a 35mm lens at a small aperture. The strength of this composition came from the "wide" view of vertical perspective. This was achieved by my being as close to the wall as possible, in order to maximize the near wall in proportion to the distant pyramid and make the latter look farther away.

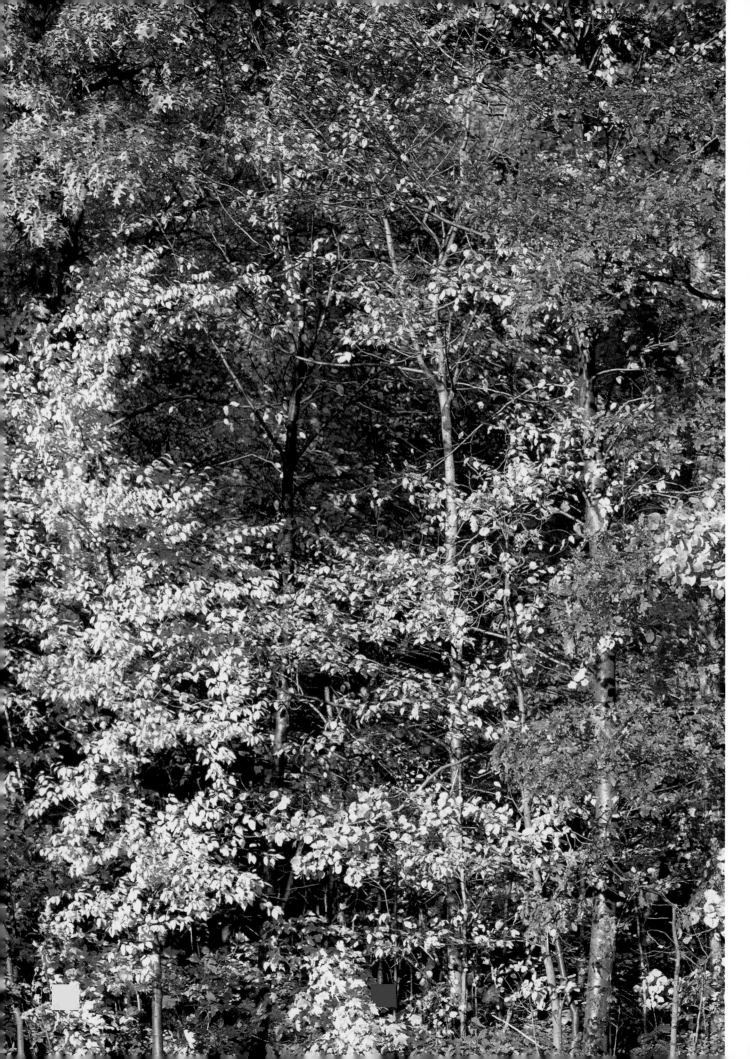

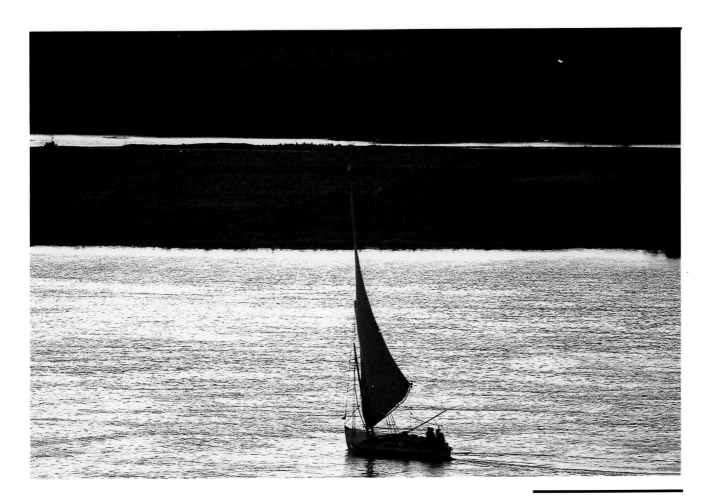

This felucca floating gracefully on the Nile one summer's evening was photographed with a 400mm lens on a tripod. Early evening—the time of the last daylight—is the time to shoot silhouettes. Water and other reflective surfaces produce sparkling specular highlights, which lend themselves to dramatic compositions.

The deep orange tint of late afternoon light was apparent in this autumn scene. The sun was low, and so the light was directional; the three-dimensional effect was caused by the sculpturing qualities of this sidelighting. The shadows were deep and dark, detail was stark with contrast, and the colors were affected by an amber colorcast. Such late afternoon light has often been called "painter's light" for its ethereality. These autumn trees were shot in upstate New York with a 180mm apochromatic lens.

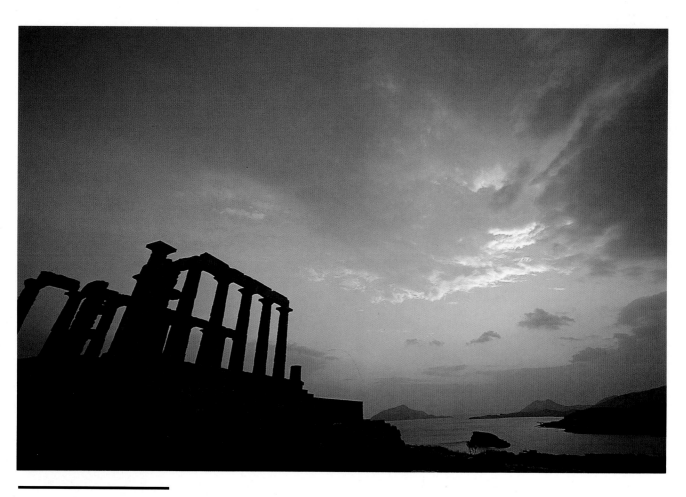

This silhouette of the temple of Poseidon in Cape Sounion, Greece, was photographed at dusk with a 15mm ultra-wide-angle lens. The camera was tilted slightly to make the structure "lean" into the background. I felt this type of construction would enhance the mythology of the scene. The darks and the lights of the exposure added a mysterious, graphic tension.

An eerie purple light engulfs the Acropolis in Athens, Greece, at dusk. The August light was fading fast, and I decided to capture the last light of day as it washed over the Parthenon. I used a 15mm lens and slightly underexposed the photograph to keep the structure mysterious and the sky deep. This is another example of changing the visual personality of the scene through the physics of exposure, choosing focal length, perspective, time, and *f*-stop to induce a particular mood, a photo-impression of a "time of day."

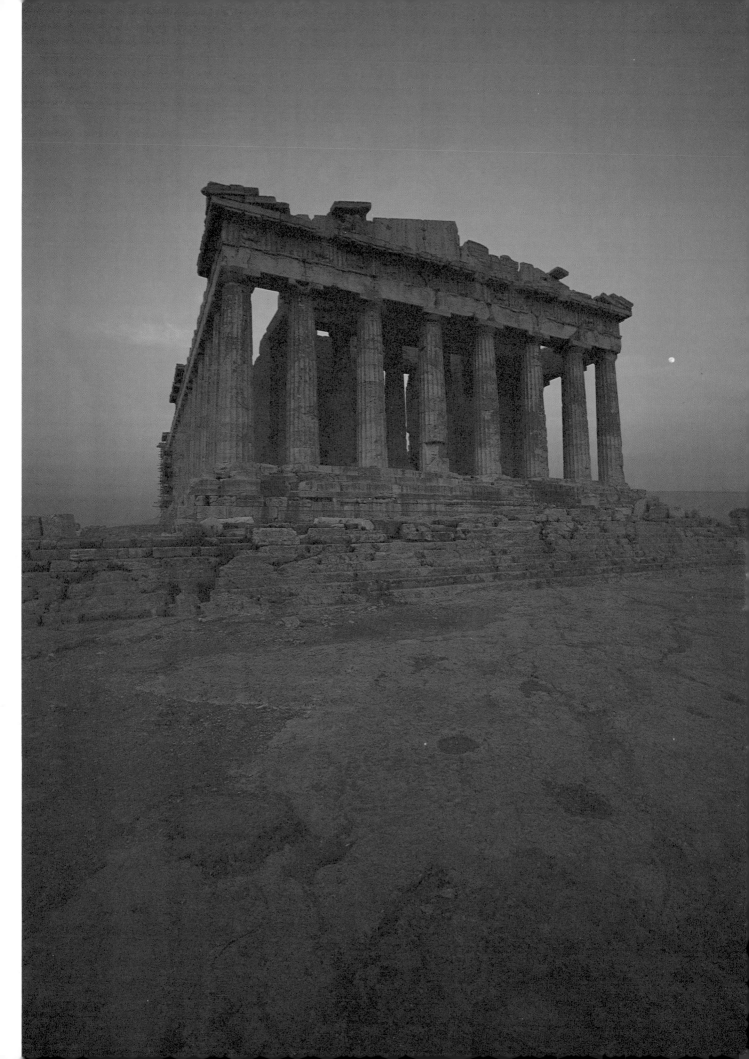

THE MOST GLAMOROUS, moving photographs of daylight can be made as the light leaves at sunset. The sky becomes a canvas of constantly changing, sometimes aggressive color, as the red light waves take over. This is the realm of impressionistic color and reciprocity failure, so be prepared for surprises when you view the finished film. All focal lengths work with a sunset: telephotos for producing huge sun disks and cloud closeups, wide-angles for compressing subjects and landscapes. Beautiful sunsets happen in every season in every locale; some of the most spectacular effects are visible in pollution-clouded city skies. Also, this is the last time of the day for long, handheld exposures.

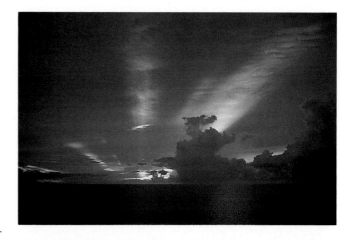

I had only a minute to shoot this spectacular example of last light over the water one fall evening in Bermuda. The scattered beams of the setting autumn sun, the weak sun itself, shrouded by clouds, and the natural haze of the sea produced an unusual combination of warm and cool colors that made the sky dazzling. I used a 50mm *f*/1 lens handheld at 1/15 sec.

The sun was a mere compositional element in this shot of seagulls on a shimmering Southern California shoreline. The personality of the scene—a warm, tranquil mood—was captured through the film's response to this low-light situation, photographed at sunset. The depth of field was shallow: the birds were sharp whereas the background blurred out of focus until the sun was a small, familiar shape, too weak in strength to influence the overall color temperature of the panorama. I used a telephoto-zoom lens set at a medium focal length.

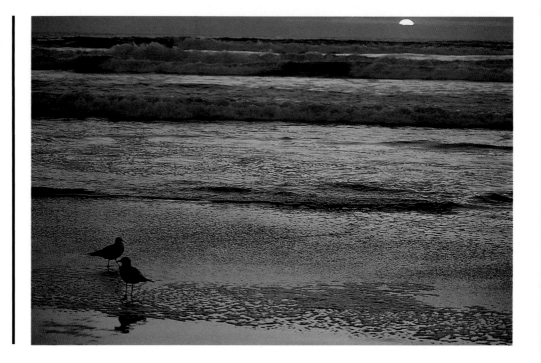

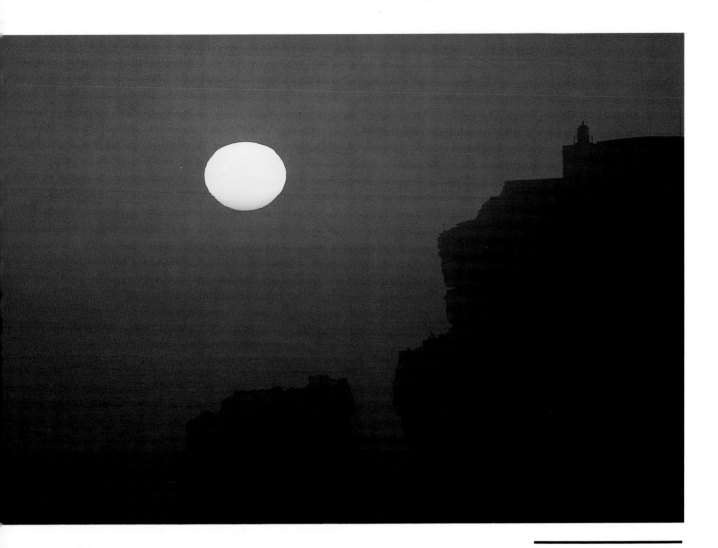

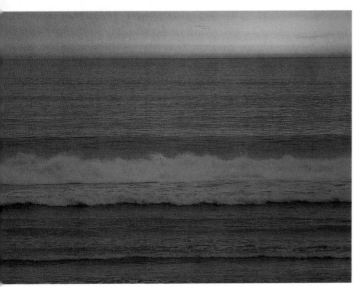

I was fascinated by the splendor of this particular sunset in Hawaii because of the pastel colors that were prevalent. The long red wavelengths of the spectrum combined with the sea mist to influence the color balance of the scene, while the long exposure time (1/2 sec. at ƒ/5.6) stretched the limit of the film's ability to record colors accurately. The result was a striking, surreal combination of "off-color" waves and surf.

The bending of waves in the visible spectrum was evident in this summer seascape photographed on the southern coast of Portugal. The light waves scatter less at sunset. This, combined with the heavy sea mist, created the warm, diffused light that gave this scene its drama. "Moodscapes" like these are directly related to natural phenomena that occur only at certain times in certain places. In any climatic condition, however, the special directional light of sunset creates atmospheric conditions photographers can exploit. Here, a 400mm lens on a tripod was used to pull the sun and the cliffs together and enlarge the sun's disk.

INDEX